CLARISSA,
SPREAD
LOVE

(RN) MOOKINB 2024...

**CURIOUS
SOUNDS**

ARSENAL PULP PRESS
VANCOUVER

CURIOUS SOUNDS

A DIALOGUE IN THREE MOVEMENTS

Roger Mooking & francesca ekwuyasi

CURIOUS SOUNDS

ARSENAL PULP PRESS
Suite 202 – 211 East Georgia St.
Vancouver, BC V6A 1Z6
Canada
arsenalpulp.com

The publisher gratefully acknowledges the support of the Canada Council for the Arts and the British Columbia Arts Council for its publishing program and the Government of Canada and the Government of British Columbia (through the Book Publishing Tax Credit Program) for its publishing activities.

Arsenal Pulp Press acknowledges the xʷməθkʷəy̓əm (Musqueam), Sḵwx̱wú7mesh (Squamish), and səlilwətaɫ (Tsleil-Waututh) Nations, custodians of the traditional, ancestral, and unceded territories where our office is located. We pay respect to their histories, traditions, and continuous living cultures and commit to accountability, respectful relations, and friendship.

Cover and text design by Jazmin Welch
Cover art by Roger Mooking, *The Other Guy Returns* (modified), 2022, acrylic on canvas and photography
All interior art © 2023 by Roger Mooking o/a SoundBites
Photo editing by Ian Kamau and Roger Mooking

Micro stories edited by francesca ekwuyasi
Essay and notes edited by Catharine Chen
Proofread by Jesmine Cham

Printed and bound in Canada

Library and Archives Canada Cataloguing in Publication:
Title: Curious sounds : a dialogue in three movements / Roger Mooking & Francesca Ekwuyasi.
Names: Mooking, Roger, 1973- author. | Ekwuyasi, Francesca, 1990- author.
Description: Art, stories, and conversations.
Identifiers: Canadiana (print) 20230225276 | Canadiana (ebook) 20230225314 | ISBN 9781551529295 (hardcover) | ISBN 9781551529301 (EPUB)
Classification: LCC PS8626.O592645 C87 2023 | DDC C818/.6—dc23

ARTWORK

For my family, here and passed.
And for my brothers, Nnamdi and I.K.

—fe

For my wife, kids, and family and
to all the artists who stare at that
empty thing and dare to fill it.
Love Only Beyond This Point.

—RM

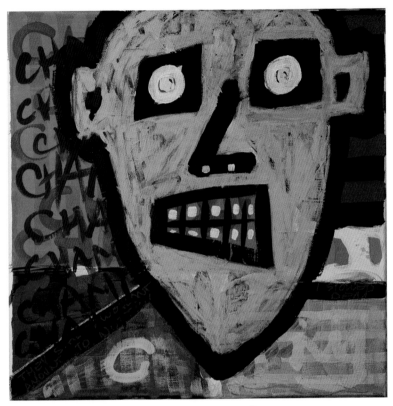

THE AUDIO INSPIRATION FOR *CURIOUS SOUNDS*

To enhance your reading experience,
listen while you explore the book:

CONTENTS

AN INTRODUCTION TO CURIOSITY

by francesca ekwuyasi

I was at a cafe, writing or trying to write, or perhaps lamenting to a friend about taxes—taxes being a stand-in for any number of tasks I must but would rather not do—or my existential dread or climate chaos or my tiny interpersonal dramas. Essentially, I was moaning about one woe or another when I received a call from Roger.

"Yo, francesca!"

"Hey, Roger!"

"I have an idea."

I met Roger in 2021 when he championed my debut novel, *Butter Honey Pig Bread*, in CBC's battle of books, Canada Reads. Our first meeting was virtual, and we talked about themes in my book—death, food, love, "madness," the malleability of time, and consciousness—via computer screens, emails, phone calls, and texts. Our conversations have stretched beyond the scope and time of Canada Reads, where Roger valiantly defended my novel to the final round—they have encompassed our practices as creators and storytellers, our value systems, shared and otherwise, and led to a camaraderie rooted in artistry, deep curiosity, and wonder at and reverence for the conundrums of being alive.

I knew Roger was working on something new because he is always working on something new. Roger is a vivid fire, endowed with a sharp and fluid energy that he directs through his many passions—music, food, visual art, and installations. Weeks before, he'd mentioned via text that he was working on some new music, an album titled *SoundBites* that was ignited by a 2015 *Time* magazine article, "You Now Have a Shorter Attention Span Than a Goldfish." The article, by journalist Kevin McSpadden, explains that, according to a study conducted by Microsoft, "people now generally lose concentration after eight seconds, highlighting the effects of an increasingly digitalized lifestyle on the brain."[1]

1 Kevin McSpadden, "You Now Have a Shorter Attention Span Than a Goldfish," *Time*, May 14, 2015, https://time.com/3858309/attention-spans-goldfish/.

Roger was eager to play with this idea of a shortened attention span through music. The album would be short—nineteen tracks with a run time of nineteen minutes. Yes, Roger has a predilection for numbers and their symbolism. I was excited about this work and had already shared my thoughts and speculations on death for some potential interludes on the album. So when I answered his call that day at the cafe, I was expecting to hear more about the music, but I also learned that it had evolved into the foundational element of a more involved creation.

"I'm working on an interactive experience, something immersive." He explained that the album would direct the art, a soundscape for the visual elements of the experience.

"I'm also writing these micro stories for each track on the album."

"Sounds dope. How will the stories be part of the work?"

"They'll be entwined thematically with the music and visual art pieces."

Then he asked if I would write about it.

I come from a family of artists of one kind or another. As a child, I thought everyone did some kind of handiwork, a craft to which they are committed, because that was what I witnessed growing up in my grandparents' home. My grandmother ran a school and invited artisans to teach us basket weaving, batik and tie-dye, and dance. She is always writing letters, queries, and memorials, even now, in her nineties. Recently she told me she wanted to write a book but worried it was too late. I told her respectfully that was nonsense; it's never too late to create. When he was alive, my grandfather told us folk tales at nighttime whenever the power went out, stories about mischievous Tortoise and his many misadventures. My mother is a painter who makes her own pigments using clay, coal, dirt, and plant material. She's also a storyteller who shares Yorùbá cultural histories through the medium of filmmaking. My cousin Chinedu is a cinematographer. My brother

I.K., a self-taught musician, produces, writes, and performs. I'm listing some of the ways different members of my family express themselves to illustrate my belief that artmaking, storytelling, and creative expression are our birthrights as human animals. As living entities occupying space and time in this particular cosmos, we are always creating. Doing so willfully, intentionally with some kind of vision, despite all uncertainty, is what interests me the most.

So when Roger invited me to join him in conversation about his art—the music, the visual art, the stories, and everything else, I said, "Sure thing."

What follows are conversations about the visual art and micro stories you see in this book and the music that informed them. However, they are also discussions about being alive, about creating with heart and curiosity, about being wild and what it means to exist in relationship to others. They are dialogues on wisdom and survival between me and my friend Roger. Together, we shoot the shit and ponder the human condition. We wax poetic about creativity as a great outlet to quell the things that damage. We embark on this dialogue in three movements that mirror the architecture of the *SoundBites* album. Please join us.

FIRST MOVEMENT:
THE LEARNING

ROGER: It starts with curiosity. Right? And the longer you make art, if you want to continue to make interesting art, by which I mean art that interests you first and then hopefully interests other people, you must keep feeding the beast. For example, as a writer, francesca, when you write a hundred words, it means that you've probably consumed ten encyclopedias' worth of words to produce those hundred words, right? Input becomes so valuable. So the more I look to create, the more I have to look outside of my immediate circumference and look to different fields of study to get additional input. For example, what is an economist saying about X? What is an astrophysicist saying about Y? Then you start to piece together the world.

That's the artist's job: piecing together, organizing the world through your filter, presenting it to people and saying, "Hey, do you understand this language too?"

So sometimes that's like a food thing for me. Sometimes that's a music thing for me. Now things have opened up into writing these stories and making these visuals, which I've been playing around with for a long time.

I have a terrible habit of turning every hobby that I have into, like, a core part of my life.

This notion of artists as a conduit, filtering everything, even seemingly discordant elements of the world, through their particular lens with the purpose of bringing forth something that is waiting on the other side, eager to exist, is an idea I've come across in my readings of Julia Cameron's *The Artist's Way*, Elizabeth Gilbert's *Big Magic*, and Rick Rubin's *The Creative Act*. It is also wisdom that I've known in my body since I was a child—not as a clearly articulated concept, but as an innate understanding. So when I read it in the

pages of those books, when I hear it in conversations with friends and collaborators, when I witness it in the processes of other storytellers and artmakers, I recognize it at once and with awe at its simple truth.

Roger's most recent album, *SoundBites*, begins with "Blank," an eight-second bell that chimes and then fades to silence, bringing to mind a call to meditation, to quiet pause. Here, I think of "The Quiet Machine," a poem by Ada Limón, the twenty-fourth poet laureate of the United States. The first line reads, "I'm learning so many different ways to be quiet."[2] "Blank" is an invitation to be quiet, if only for eight seconds. Though I'm a novice meditator, my years of inconsistent practice are attempts to intentionally listen into the quiet. To listen and notice, listen for God, listen to the soundtrack of my interior worlds, listen to my fears and find what is true there, listen for the things that could buoy me through them. To listen for the stories that are asking to be told. I have an altar in my bedroom at the base of the boarded-up fireplace that is the room's focal point. Among candles, flowers, cowrie shells, pictures of family who've passed through this place and gone elsewhere, and a small, round glass flask filled with clear spirit is a small copper singing bowl that I strike with its accompanying mallet to mark the start of my prayers and meditation.

Similarly, "Blank" marks the beginning of the first movement, a sonic signalling to the idea of the eight-second attention span. As if to say, "Now that I have your attention ..."

FRANCESCA: How did you come to meditation? Did it have anything to do with your experience with ADHD?

ROGER: I was recently divorced and going through a hard time, and you try to find your way around, try to

2 Ada Limón, *Bright Dead Things* (Minneapolis: Milkweed Editions, 2015).

manoeuvre through this blockage or get beyond it, try to grow past it. I was introduced to this monk, and for five years, I trained with him for three, four hours a day. There was a lot of meditation, you know, an unusual amount of training, but this is my way. When I decide I'm doing something, I obsess about it. So I became obsessed with meditation and training. Any time I'm able, I share that with anybody. I think it's love to share it with people, because it's opened up everything to me. I wouldn't have the patience to sit down and make all these visuals and paint like this without practice.

FRANCESCA: I think that hyper-focus can be a symptom of ADHD. So when you're into something, you can really just zone in.

ROGER: Yeah, everything else disappears.

Complete absorption in the task at hand that leads to a loss of self-consciousness is "flow state," a term coined by Hungarian American psychologist Mihaly Csikszentmihalyi. He developed the idea in the 1970s after conducting extensive research on happiness, creativity, and peak performance. At certain points in my own creative practice, I have found myself syncing seamlessly with the process, every detail becoming a gorgeous revelation. I've entered this state even while engaging in the most mundane tasks, like washing the dishes, folding a massive pile of laundry, or cooking. It is, for me, one of the many delicious gifts of intentional presence and moving mindfully, something I learn, forget, relearn, forget, and relearn again through the practice of meditation. Another lesson I'm constantly learning is how disparate forms can coalesce in the most peculiar ways to forge something whole and extraordinary.

FRANCESCA: So there are four distinct parts to this: the album, the visual art, the micro stories, and the book, which effectively ties them all together. I'm curious as to why. What is the significance of each element you've chosen, and how did you choose them? The music makes the most sense to me, because that's how I came to know you as a musician and a chef.

ROGER: They are things that interest me. I've been a music writer and producer for so many years, and I've been more focused on creating music that feels visual. I was messing around doing all kinds of stuff with photography and acrylic paints for a while. And I came up with some ways of making really fun and interesting representations of many similar ideas to the album. I began treating all the visuals like sampling in music, taking bits and pieces of the paintings I'd created and piecing them together to create these final images. So the visuals are a vital component, and in terms of the stories, I'm accustomed to writing ideas in short form from writing songs. So, similar to the more shortened form of the music, the stories are limited to one hundred words at most. It was just fun to play with mediums on top of mediums.

So it came out of playfulness. What I find most poignant about this body of work is Roger's playfulness and unabashed curiosity as he deftly wields familiar mediums—storytelling through music and visual art installations—and experiments with new ones in the form of fiction (micro stories).

In all its various possible forms, storytelling is one of my first loves. I come by it honestly. As a teen, my oldest brother, Nnamdi, regaled us siblings and cousins with harrowing tales of boarding school life. With mischievous humour, he told us of cruel senior

students and their sadistic bullying, of hopping over the school fence—topped with shards of broken glass—and into the forest behind the sprawling school compound, of the urban legends of ritual headhunters on the prowl for the heads of wayward schoolboys. Oscillating between sombre and piss-yourself hilarious, terrifying and tender, Nnamdi could tell a good story. This was also true of my grandfather, with his many tales of the wily trickster, Tortoise. It is true of my cousin Ivy, who often had me in stitches, clutching my belly in pain from laughing so hard over her dating mishaps. My grandmother still tells the most epic tales of her time as a schoolgirl; her anecdotes are flawless, and she's constantly spitting gems. So I'm always down for a good story.

Roger's micro story "Peace," inspired by the album's first track, reads just like a fable—in fact, most of the micro stories in this collection do, to one extent or another, with vivid imagery, anthropomorphism, and a moral—though not always a clear or direct one.

> ROGER: So "Blank" is a blank slate, a beginning. It's peace and tranquillity. "The boulder rolls heavy down the mountainside. It splits its head open without a sound." There's a kind of peace, but there's a journey ahead, and as it falls, the rocky appendages flail, and they all fall together. They rest for eternity. So it's like we are now prone, awaiting what is next. This shows the materiality of boulders and rock formations to drive back the notion of vast amounts of time passing, and I feel that visually, it's like we're tumbling into the world. And then we fall, and we're prone, and what's happening now? What's next?

What's next is "Aquatic Inferno," the second track of the album, and its accompanying micro story, "This Is the Time." Here, I want to begin with the music, because music is my other first love, and I cannot write about music without first writing about my father.

His baptismal name was Francis—I'm somewhat named after him. Francis died when I was about five years old. My memories of him are sparse and hazy. I recall him lying on a curtained-off bed in my grandparents' house, attended to by a nurse in the last few days of his life. I cannot know if these memories are entirely accurate, but they are all I have of my own; the remainder of what I know about him is woven together from other people's memories, stories from folks who knew him while he was alive. One prominent thread in all their stories is his love for music. Like Francis, my brother I.K. is a wildly gifted musician, passionate about sound and all the ways it can be sculpted. When he first decided to pursue music as a career, our grandmother disapproved.

In I.K.'s words:

Basically, I had been working at the radio station Rhythm 93.7, and the family was trying to get me to leave Nigeria for school. We tried so many places, tried for the US a few times, tried for the UK, but none of it worked. And while all that was happening, I was working in the music library at Rhythm, which meant I was listening to all kinds of music from all different times. So it made me more interested in sound. I had always been interested, but this experience made it all click. While I was trying to get into school, I decided, you know what, I want to take my life into my own hands and start getting into creating my own music.

I told Grams—she might not remember this, but she mocked me, she was mean. She said, "So you want to dance for people to be spraying money on you like Sunny Adé?!"[3] She was very dismissive. But she eventually

3 King Sunny Adé is a Nigerian jùjú singer, songwriter, and multi-instrumentalist. He is considered one of the first African pop musicians to gain international success. He has been called one of the most influential musicians of all time. A family friend, he performed at my grandfather's wake.

became supportive when I built the studio and started doing the music thing. That's when she told me that our father did the same thing. She said he brought some music equipment into Nigeria, like mixers and sound stuff, intending to set up a studio, but I don't know, he didn't do it. I *do* know that he taught all his siblings about music. Uncle John and Uncle Clem, he taught them to play musical instruments by ear. And as far as I know, yes, he taught Uncle John how to produce music. Uncle John went on to produce Uncle Aleke's album.[4]

Fun fact about that album: Wynton Marsalis, who is a Grammy Award–winning trumpet player now, was on that project in 1980. Check it out, Wynton Marsalis played the trumpet on that project that Uncle John produced! That's what Uncle John told me. He also told me that our father was way ahead of his time regarding his knowledge of music. When Popsie [our father] was in school in America, in Boston, he took this alternative music theory class and learned so much about up-and-coming artists. He would talk to his siblings about what he was learning, naming bands that would eventually become very successful and change the sound and culture of music.

I have to start with the music because it's in the blood, quite simply, and where "Blank" is an invitation to silence and a marker of beginnings, "Aquatic Inferno" is a decisive plunge into being. The song runs fifty-eight seconds long and begins with two distorted voices—one weighed heavily by bass and the other pitched higher—layered over each other. Seven seconds in, an ethereal hymn takes over. Haunting and celestial, it gives a sense of being

4 Aleke Kanonu, a friend of my father and uncles, passed away a few years ago. The album I.K. refers to, *Aleke*, was created in 1980 and can be heard on YouTube: https://www.youtube.com/watch?v=khhAdcGyO4A.

suspended in a state of transcendence, but only for a moment, because the distorted voices resume over the hymn, creating a rhythmic stutter. The contrast between these two elements is a captivating opening to the rest of the song. The words that emerge in a skewed staccato voice, "every single element on Earth, in the trees, in the park bench, in the cement, in your body, in the ocean, in the air, was created by …" are an excerpt from a conversation between Roger and physicist Louise O.V. Edwards on the origins of everything.

The accompanying micro story, "This Is the Time," is concerned with just that: origins, conception, and birth.

> **ROGER:** To me, it represents the womb. Think of what the womb is like: this charged cell structure with so much energy and cells dividing and subdividing, all immersed in liquid. So this is the "Aquatic Inferno."

A bright smear of colours—various hues of blue, yellow, green, pink, and white—streak and swirl around a subtle light, with the word "help" floating in its centre. This is Roger's depiction of the "Aquatic Inferno" from which comes birth. A birth is often, ideally, a reason for celebration, and "Its My Birthday" is a fitting accompaniment. The track is ignited by the sound of a spring—a metallic, resonant *boing*—followed by bold, energetic horns. The opening lines repeat, a refrain throughout the one minute and seven seconds of the song.

> *You know it's my birthday*
> *My birthday*
> *Happy anniversary to me*
> *It's just an Earth day*

An ode to innocence, to the simple joy of mere existence, and to beginnings.

I like new beginnings; I'm a sucker for fresh starts. One of my best friends, Hannah, often wishes me, "Happy Fresh Start! Happy New Month! Happy New Beginning!"

ROGER: So after the womb, you're born, right? This is really born from a couple of ideas, one being that I don't celebrate birthdays. Well, that's not true. I celebrate my birthday daily. It's my belief that every day, you wake up with breath in your lungs and the capacity to do what you need to do—that's your birthday. You're reborn every single day. While you're asleep, your mind is flushing out ideas. Your body is cleaning up the dead cells like you are physiologically replenishing your body every night. And every day, you're a new person. And so you're born every day. This is what the real concept of the track is, but also it's like, I always want to have a birthday song. Right?

Right.

Here, two ideas come to mind.

One: Listen, I have theories about what exists beyond the doorway of death that I'd love to share with you another time. But for now, for the beginning of beginnings, being born is an invitation to witness and partake in the astonishment of aliveness. To be born, to be alive, as far as I can fathom, is to be in a position to experience awe.

Whoa
So isn't this amazing
Everything is so loud
.

And it's bright too
So many things to get used to

In his most recent book, *Awe: The New Science of Everyday Wonder and How It Can Transform Your Life*, psychology professor Dacher Keltner comprehensively examines the emotion of awe as a transformative force.[5] He emphasizes the importance of seeking out awe-inspiring experiences because they can cultivate lasting positive changes in our brains, increase our well-being, and promote creativity and a robust sense of meaning and purpose.

I adore this book and Keltner's research on awe in general; it's always deeply affirming when scientific study supports what I experience as innate, embodied knowing. Whenever I recall delightful childhood experiences—and I'm certain I do this with much nostalgia that, very likely, renders the memories fairly unreliable—I am struck by how much more easily I was moved by awe in early life.

Whoa
So isn't this amazing
Everything is so loud
.
And it's bright too
So many things to get used to

I think the point is to try not to get "used to" the magnificence of existence, to refrain from taking even the most mundane for granted, because it never ceases to be sublime. Keltner's work compellingly reminds me of the capacity of awe to transform. He provides tangible ways to reignite that sense of wonder that

5 Dacher Keltner, *Awe: The New Science of Everyday Wonder and How It Can Transform Your Life* (New York: Penguin Press, 2023).

seemed so much easier to access in childhood and to deepen our connection to the world around us.

Two: the track "Its My Birthday" elicits in me a profound sense that approaching all things as a beginner can offer a sense of freedom. I am reminded that every day can be an opportunity for renewal, a chance to shed the weight of the past and embrace the potential for transformation. The beginner's mind, or shoshin (Japanese: 初心), is a concept from Zen Buddhism that refers to an attitude of openness, eagerness, and lack of preconceptions in approaching everything, despite the learner's level of experience or mastery. This concept is why I've come to refer to myself as a "learner" and the reason I practise engaging with everything I come across as one. Because I learned about mindfulness and meditation through books and apps on my phone, I've only ever practised alone; now and then, I worry that I'm doing it "wrong." So the idea of approaching meditation with a beginner's mind, as well as everything else, really—my craft as an artmaker and a storyteller; my relationships with others, myself, my body, and my mind—brings me comfort, the freedom to play, to experiment, even to fail. Then to repeat it all again, back to learning and failing and failing better.

On my best days, I don't believe in failure; as my friend Nik says, "You win some, you smoke some." I translate that to mean that sometimes you meet the mark, and sometimes you learn. When I intentionally approach my life as a novice, when I entertain every new circumstance as, in fact, *new*, I am receptive to more ideas and possibilities than I could have imagined. I am better equipped to avoid the limitations that come with assuming I know all there is to know about any given topic. I am met with surprises, and even better, I am given opportunities to shed the hubris of being jaded, of thinking I already know what's what.

The micro story accompanying "Its My Birthday" homes in on themes of childhood, play, and the embodied emotions of celebrating life.

After playing themselves silly, the restless children finally fall asleep. When they awake, cool air fills their lungs, and they tumble anew into the day. Together they sing, they dance and celebrate, because it is their birthday.

On a recent episode of *On Being with Krista Tippett*, one of my favourite podcasts, American record executive and producer Rick Rubin and journalist and author Krista Tippett speak about living a creative life. Rubin, a creator in his sixties who has, in Tipett's words, worked as "a kind of a midwife to bringing art and music and beauty into the world," muses on the critical nature of play and experimentation in the creative process.

TIPPETT: All of this stands in contrast to a lot of the ways we're conditioned, right?

RUBIN: Yeah, getting out of our own heads. Getting out of what we were told, you know? Getting out of what we were taught. Being free.

TIPPETT: We're so purposeful. *[laughs]*

RUBIN: Yeah, being free to experiment.

TIPPETT: Right.

RUBIN: Being free to have fun and experiment. And if we find a new way to do something, to embrace it instead of thinking, "Oh, that's the wrong way." You know, the

reason I made the hip-hop records that I made—I made them the "wrong way." I didn't have the baggage of the "right way."[6]

The baggage of the "right way" really struck me, and it loops right into track four of *SoundBites*, "Im An Adult," from the second Roger's voice booms through.

Lemme tell ya
I'm an adult and I don't know shit
I'm like you
I'm just winging it just like you

I dig the humour of the bars lacing through the smooth, laid-back grooves and syncopated rhythms of the beat. I tend to learn with more ease and to enjoy myself when I can create without the weight of performing intellectuality or even expertise, because even though I'm an adult—perhaps *because* I'm an adult—life always seems to come up with new and fascinating ways to remind me how little I know about how little I know. As Roger says, "I'm an adult and I don't know shit." In the words of James Baldwin in "Conversation with a Native Son" (with Maya Angelou in 1975), "When I was young, I knew a lot. Now, I don't know nothing, which is a great relief."[7]

Recently, I learned something that fills me with a sense of both unbridled awe and existential terror: a vast majority of the matter in the universe is imperceptible to human senses. According to

6 Krista Tippett, "Rick Rubin: Magic, Everyday Mystery, and Getting Creative," *On Being with Krista Tippett*, March 16, 2023, podcast, https://onbeing.org/programs/rick-rubin-magic-everyday -mystery-and-getting-creative/.

7 "Assignment America; 119; Conversation with a Native Son," produced by Thirteen WNET, May 13, 1975, American Archive of Public Broadcasting (GBH and the Library of Congress), video, http://americanarchive.org/catalog/cpb-aacip-75-48sbchq4.

current understandings of the universe's composition, normal or "baryonic" matter, which includes everything we can directly observe or interact with, such as stars, planets, and galaxies, accounts for approximately 5 percent of the total energy and mass content of the universe. The remaining 95 percent is made up of dark matter and dark energy, neither of which is directly observable by human senses or using any existing detection methods. Dark matter is an invisible form of matter that does not emit, absorb, or reflect light, making it undetectable by our senses or standard telescopes. It is estimated to make up around 27 percent of the universe's mass-energy content. Dark energy is an even more elusive form of energy that is thought to be responsible for the accelerated expansion of the universe, and it accounts for approximately 65 percent of the mass-energy content.[8] [9] [10]

Isn't this the most absurd, mind-boggling, awe-inspiring, brain-shifting information? It is to me. Perhaps this is basic data to theoretical particle physicists, but to a layperson like myself, this truly rocks my world. We quite literally cannot perceive and thus cannot know, as of yet, the vast majority of what is around us. So, to put it plainly, in relative terms, we don't know shit. What a delight!

> **ROGER:** The Learning is decidedly simple; we bask in this juvenile fervour. Sparse in all aspects yet with an overwhelming number of new insights, this first movement lays out a rudimentary architecture. The garishness of this first third of *SoundBites* is significant and foundational.

8 "Scotohylology (DARK MATTER) with Dr. Flip Tanedo," *Ologies with Alie Ward*, podcast, February 8, 2023, https://www.alieward.com/ologies/scotohylology.

9 "What Is the Universe Made Of?" *WMAP Universe 101: Our Universe* (NASA), last updated January 24, 2014, https://map.gsfc.nasa.gov/universe/uni_matter.html.

10 "Dark Energy, Dark Matter," *NASA Science*, last updated June 9, 2023, https://science.nasa.gov/astrophysics/focus-areas/what-is-dark-energy.

Trapped in the ninety-second boxes of each song, the structure creates tension and release.

Track five is an interlude, a comic skit titled "Francescas Reading Room." The corresponding painting, a portrait of a figure with a shock of bluish hair and what resembles a letterman jacket embellished with a prominent W, is evocative of Jean-Michel Basquiat's *Dos Cabezas* (a 1982 self-portrait of the artist with Andy Warhol) as well as his 1984 *Self-Portrait*. In a conversation about this painting, Roger mentioned that the figure could be interpreted as a personification of Mr. White, the protagonist of "Based on a True Story," the micro story that accompanies the painting. Mr. White is a seeker, a reader, and a learner who, like many artists and learners I know, heeds the directions of his inner voice.

Reminiscent of the relentlessly cool and politically conscious poetics of the hip-hop trio Digable Planets, track six of *SoundBites*, "Pretty Penny," opens with the soulfully crooned lyric "She was a pretty penny," followed by Roger's barefaced retelling of a story of colonization and exploitation, the cadence of which, he says, is an homage to the storytelling style of Slick Rick.

Born Richard Martin Lloyd Walters, rapper and producer Slick Rick rose to prominence in the late 1980s and early '90s and is often referred to as hip hop's greatest storyteller. Known for his incredibly vivid narratives, memorable characters, and striking wit and humour, showcased in his deft use of multiple points of view, voices, and even accents, his influence on Roger's "Pretty Penny" is evident.

> ROGER: It's a fairy tale about a child who finds a gold coin on the ground, realizes that this coin is special, recognizes that there is a person on it, and wonders how his life circumstances are so different than that of the person on the coin. Then he starts to understand the lineage and

the history of this person, the dubiousness and maliciousness of it. I really wanted to address all of my frustrations around colonialism and the various monarchies of the world and how those two things have ravaged people from the African diaspora globally. I wanted to package it as a fairy tale. I don't know if we need another essay explaining the gravity of the history of colonialism, racism, and slavery. There are a lot of really amazing books about that. We need to write books about a great future, right? So this is why I chose the medium of the fairy tale as opposed to heavy-handed prose. I'm a fan of juxtaposition.

I wrote this story called "A Curious Mind." This is one of the micro stories that is closest to the song. A child finds a lump of gold by the river. It's brilliant, and it's heavier than normal, so he knows that it's special. He takes it to a shopkeeper to understand what this gold thing he's found is, but the shopkeeper manages to take this golden nugget from the boy. The shopkeeper decides to hide it away for a rainy day, only to realize after some time that it has been stolen by another rat. So I guess the shopkeeper is the first rat and was found by another rat. Maybe it was another human rat. Maybe it was a rat rat that liked shiny things.

FRANCESCA: Is there a reason you left the story open ended?

ROGER: If something is left open ended, the reader must fill in the blanks. So it makes you ask the question, "What do you mean, 'another rat'?" Like, was there another rat there? Is this child a rat? Is this a community of rats? Nowhere do I say that there's a human; there's only a

32

child, a curious child. There's a shopkeeper. But in the sense that it's a fairy tale or just fictional storytelling, it could be a community of rats.

I'm a fan of fairy tales and fables. I was an early reader because my grandmother seriously encouraged it. My aunty Anthonia got me a copy of *Aesop's Fables* for my eighth or ninth birthday. I loved that book and read the fables over and over, until it became a tattered mess. As I write this, I sincerely regret that I have no idea where it might be at this moment, twenty-something years later. The fables often, if not always, concluded with a clear teaching on morality that summarized the lesson woven throughout the story, emphasizing virtues such as honesty, humility, kindness, wisdom, and hard work, while also cautioning against vices like greed, pride, and deceitfulness.

Roger's fables, on the other hand, leave room for ambiguity. You, dear reader, decide what the moral of the story is. To my ears and in my thinking, the moral of the song "Pretty Penny" and the story "A Curious Mind" is that the legacy and the consequences of the enslavement, colonization, and exploitation of Black and Indigenous people and people of the global majority run deep and deadly and colour even the stories we know and tell about it. The words of British historian and politician John Emerich Edward Dalberg-Acton come to mind—"Power tends to corrupt, and absolute power corrupts absolutely"—but I think the notion requires troubling. I believe power is neutral and takes many subtle shapes, not merely force or domination. It's cruelty that corrupts, as well as intentional, strategic, systemic dehumanization for profit and gain. But back to the child with the shiny coin in "Pretty Penny"—after all his learning, he returns home and gives the coin away:

So the boy with his smarts took the coin to his mother
and said
"This is for you, Momma
You earned it"

ROGER: When you first listened to *SoundBites*, your initial comment was that it felt urgent, which I thought interesting. On purpose, the song tempos tend toward a mid-tempo sort of meandering stroll. The ninety-second form factor really played with all of my music-producer instincts. Song to song, I no longer had the ability to lull the listener into the soundscape I was about to take them on with instrumental groundwork, musical breathers, and bridges. In a short ninety seconds, the song's idea and its feeling had to be immediately immersive. I thought of it like falling into a black hole, not knowing where you will exist in the next moment, and suddenly being spit out into the next song. We are not used to listening to an album with such immediacy of thought, and despite my best efforts to balance the barrage of emotions throughout the album, the urgency prevails.

In the narrative arc of this concept album, it is here, toward the end of the first movement, the Learning, that the proverbial/archetypal child begins to grasp the lesson in things. During a conversation with Roger in February of this year, we walked through Jean-Talon Market in Montreal, wandering past colourful mounds of fruit and flowers as he told me how his musical palette was heavily influenced by his father's record collection. He was at an age when he could grasp the benefit of his father's eclectic musical tastes. Music also runs in the blood for Roger; his brother was a DJ, and he himself learned to build sound and create music, always in service of whatever core emotion needed exploration.

The influence of family in our craft is a trait we share, as is evident in the next track, "Listen To Granny." With a total running time of forty-one seconds, the song opens with the voice of Roger's aunt, Claire Prieto:

Yeah, that's right baby, just uh, don't forget to call your granny.
You know how she likes to talk. Just listen to your granny.

Her voice plays over a beat pattern in a driving rhythm that is easy to nod your head along to. Roger's rapid-fire storytelling swiftly follows:

Trapped between
Vanity and insanity
The same way it is now
It was with my granny too
Granny one was a martyr
And granny two
Was even harder to get through to

ROGER: So in "Listen To Granny," we're still in the learning phase. And it's really about respecting your elders. There are a lot of cultures around the world that adhere to that idea. I grew up in a part-Chinese family with a West Indian background. You don't mess around. You respect the elders, you know, and the community raises the children. It was that type of environment. So listen to your granny; she's got a lot of stuff to teach. It also references my life specifically. My two grandmothers were very powerful women leaders of their families. And [on the track] I say, "trapped between vanity and insanity." My grandmother on my father's side died after years in a mental hospital. On both sides of my family, there is

a very long history of mental health issues, like severe mental health issues. Living and dying in a mental hospital type of severity.

FRANCESCA: Right, you mentioned this when we first met in 2020.

ROGER: Yes, this is the story of my grandmother and, like, West Indian women. They are very proud. They could be poor as dirt, but when they come out of the house, their hair is done, and they smell fresh, like lavender and coconut oil. They're beautifully dressed, and their shoes shine. Nobody on the street knows they don't have a penny for a piece of pigtail. But they're proud. Right? But then they walk around with all these mental health issues as well. So that's why I say "trapped between vanity and insanity."

The visual piece for this track is a digital collage constructed with snapshots or samples of paintings composed of yellows, pinks, and blues in low saturation, faded. The words "SANITY VANITY" are laid boldly over the paintings, giving the collage a fashion-editorial sensibility that underscores the theme of attention to beautification and adornment despite one's circumstance.

I think of my own paternal grandmother, Cordelia. A matriarch, she ran a house full of grandchildren, niblings, cousins, and second cousins; I was raised by the small village in my grandparents' house on Awolowo Road in Ikoyi, Lagos. My grandmother, aunties, and older cousins taught me what was what. So I very much identify with parts of what Roger describes as his childhood.

Last November, I went home to see my grandmother and recorded her as she told me a story about getting into trouble as a schoolgirl. She's in her nineties now, but I swear, time shifted

sideways when she spoke, and I saw her as a young girl giggling with her classmates at school. She has one of the sharpest minds I've ever encountered. I knew this even when I was younger, because she seemed to recall obscure details about everything so easily. She recalls phone numbers and is able to do long division in her mind—I'm not sure I even remember how to do long division on paper! I barely recall birthdays if my calendar doesn't chime a reminder the night before. I've become entirely reliant on my phone for banking, passwords, and phone numbers and addresses.

You couldn't get away with anything on my grandmother's watch. She comes from a large family; she's had to hold so much, to build and rebuild many lives throughout her years.

I am certain that there are things she knows casually that I cannot yet begin to fathom. And listen, I'm not romanticizing her—I couldn't even if I tried. She is flawed and complicated, with a more vast history than I can ever know. These are just a few facts about her, so I'm down to listen to whatever she says.

I wept when I first began to read American author and psychotherapist Resmaa Menakem's *My Grandmother's Hands*. Though the book focuses on racialized trauma experienced by Black communities in the United States, it brought to mind my grandmother's own story of growing up under British occupation.

Throughout the 1920s, when my grandmother was born, the British established a colonial administration that exerted control over Nigerian people and territory. They implemented policies, laws, and regulations that served British interests, often at the expense of the Indigenous Nigerian populations. While the British did collaborate with local leaders through indirect rule, the ultimate authority remained with their colonial administration. Nigeria underwent significant social, economic, and political changes as the British sought to develop the colony's infrastructure, exploit its natural resources, and introduce Western-style

education and political systems. These developments laid the foundation for Nigeria's eventual independence movement, which gained momentum in the mid-twentieth century.[11] [12]

In *My Grandmother's Hands*, Menakem explores how intergenerational trauma is passed down in families, through learned behaviours and social conditioning, yes, but also on a physiological level.[13] Similar to the work of psychiatrist Bessel van der Kolk in *The Body Keeps the Score*, Menakem posits that the body holds on to trauma and that future generations can inherit these traumatic responses. This means that the descendants of individuals who experience racialized trauma such as slavery or systemic racism may continue to carry the effects of that trauma in their bodies, even if they haven't directly experienced the traumatic events themselves.

Although I will likely never know the specific details of my grandmother's particular traumas, I've witnessed echoes of them in the ways she ran the household, the ways she expressed her emotions, the ways she chose to discipline us when we were children, the language she uses, and her relationship with her children, then and now. I feel them too in the waves of my interior landscape; sometimes an ancient sorrow flares open in me, and I don't know why. I lose time to a pain I cannot always point to. I lose time, and I am lost, and I want to ask my grandmother, *What happened? And why does it hurt so much?* (This question could also be for my mother, the woman whose face, precise features, and mannerisms I possess. People have referred to me as her carbon copy. The question could be for any and perhaps all of my ancestors; this is why I keep an altar to honour them.)

11 Toyin Falola and Matthew M. Heaton, *A History of Nigeria* (Cambridge: Cambridge University Press, 2008).

12 Michael Crowder, *The Story of Nigeria* (London: Faber and Faber, 1978).

13 Resmaa Menakem, *My Grandmother's Hands: Racialized Trauma and the Pathway to Mending Our Hearts and Bodies* (Las Vegas: Central Recovery Press, 2017).

On the flip side—because there's always a flip side—on my best days, I'm fiercely in love with being alive. I am confident that life is for me, and I am for life. I know that this too is from my grandmother and the lineage of life before me.

The counterpart to "Listen To Granny" is "Trapped Between," a fable about the discordance between elders and the generations after them. The elders will not be disturbed by the villagers' concerns over a curious sound.

> **ROGER:** This is a story about a sound that has interrupted a village. The villagers go ask the elders what to do about the sound because they respect them, but the elders are disturbed and perturbed. Are they disturbed and perturbed by the sound? Are they disturbed and perturbed by being distracted from whatever joys they are trying to have at the moment? It's sort of this notion of the community speaking to the elders. They sought their advice because, hey, they listened to granny. And it's just like a microcosm of society with generational interplay.

As if emerging from the silence left by "Blank," the closing track of this movement, "Practice Daily," revs up, peaks, and fades out in all of twenty-eight seconds. At the ten-second mark, the resonant ringing of what sounds like a bell vibrates through the remainder of the song. The callback to "Blank" is a fitting conclusion to a period marked by emergence and the initial forays into learning. Even without considering all those layers, the song is a straight-up banger. Roger's enjoyment is palpable.

> **ROGER:** You know, [the track is] a lesson in discipline. Something to practise daily. So I wrote this song because I just love rapping. I practise rapping. The song is not

about anything in particular, other than I love to rap—it's so fun, you know? It really is that simple, and I love the beat. In the first movement specifically, as you move through the album, you hear it has a juvenile tone, a playfulness to it. The lyrics are quite simple, like "Its My Birthday," "Im an Adult." They're very comical, playful, simple deliveries. The cadences and the tone are child-like. The pitch of my voice is a little bit higher and more angular. So all of those things play in real performances. The sound of the music, if you listen to the instrumentals in this first movement, is most stripped down and very simple. In many ways, this is the learning phase; we're a blank slate. We're building our person, and so this person will be very decidedly juvenile, playful, and childlike.

FRANCESCA: Is this playfulness also reflected in the visual art you've created specifically for the sound?

ROGER: Well, I think it's a multitude of things. I'm born in Trinidad, which is a very playful island. For example, it's an oil-producing country, and there are a lot of oil drums kicking around the Caribbean as a result of this. The oil drums that landed in Jamaica, they turned into pits to cook food, the jerk pit. The oil drums that landed in Trinidad, we turned into steel pan so we could play instruments to have a party.

So I think the essence of being Trinidadian means I possess a natural playfulness. I grew up listening to a lot of old calypso. My dad has cassettes and cassettes of old-school calypsos, and if you listen to the old-school calypsos, it's not like the music you hear now. The songs are very thoughtful, and there are a lot of double, tri-ple, and quadruple entendres. There's a lot of innuendo,

insinuating things, cloaking things in symbolism, a lot of politics, a lot of relationships told in very fun and playful ways, you know?

So I think that's the spirit [in my work]. I was born in that country, and that spirit just lives with me. And no matter what I do, there's always some element of playfulness. Visually, in the context of attention deficit, I want to translate the sense of feeling a barrage of things.

I often feel a barrage of things, a twisted knot of emotions—frayed, tangled, loose in odd places, too taut in others. As time passes, though, patterns become familiar. I am coming to see even my most affecting feelings more and more clearly, coming into a capacity to anticipate and accept them, because I know myself better as I am becoming. That is to say that the newness of childhood, so blithely depicted in the tracks of this first movement, is marked by intensity and a pace reflecting gradual maturity. The subsequent movements of the album follow a similar arc; however, the vividness of first experiences is captured most distinctly here, from the bounce of "Its My Birthday" to the swing and simplicity of "Im An Adult." The energy of this movement, like the season of childhood, is not only contained in beginnings. One of the fruits of a beginner's mindset is the elastic capacity to access awe in any season, at any age.

SECOND MOVEMENT: THE LIVING

FRANCESCA: Can I ask you a question about your father?

ROGER: Of course, ask me any question on Earth.

FRANCESCA: Is he in your life?

ROGER: Yeah, he's in my life. He lives in Alberta with my mom, and they live in the same house I grew up in.

My father is a fascinating man. He was, like me in some ways, born to take care of people. From a very young age, he was responsible in many ways for taking care of the family, emotionally and socially and financially. He was still just a boy when he had to be the person to call the police and ambulance to come get his mother out of the house and put her in the mental hospital. He put his brother through university. He took on the role of patriarch after my grandfather left the household, at I can't remember what age. But he came up taking care of people his whole life, and we share that same lot in life.

Since the start of COVID, my dad has not left the house. He doesn't even go to the grocery store. For almost three years now, at most, he goes to the backyard and sits on the porch. He is a very clever, engaging guy, likes to talk, cook food, and have fun with his friends and family. But with COVID isolation and depression, he fell into a really bad cycle—it's been really bad.

My father used to own a restaurant in Bonaire in the Netherlands Antilles, for twenty years, which he bought from his father. So he would leave for many months of the year to run the restaurant and then come back to Edmonton. And then live with us for a few months and then go back to the restaurant, that kind of thing. So that was most of my childhood growing up.

When he was home in Alberta, I would see him down on the chair in the basement, and he would sit there for hours every day or every few days. I started asking him, "What are you doing?" I'm like, "Oh, what's that?" and he's like, "Oh, I'm meditating." So he introduced me to meditation just by observation.

My father has been in the food and beverage industry. His father came before him to open the food and beverage industry for our family. He was a baker. My grandfather became famous in Trinidad for selling strawberry cake. Now, what's interesting about that is there are no strawberries in Trinidad. He learned food science way back in whatever this year was, and he would take the seeds of tomatoes. Check out what he's doing: he used to extract the seeds of tomatoes and dry them out in the sun to get the little pits, like the seeds on the strawberry. From food science, he learned how to engineer strawberry flavour. So he made cake, put some red food dye in, and added the taste of strawberry and all the dried seeds from the tomatoes. And he sold strawberry cake, and he became famous in Trinidad.

FRANCESCA: You're very much in line with your family craft regarding food and creativity, spirituality, and travel.

ROGER: Yeah, I think so. And also, on my mother's side, my uncle is a well-regarded photographer in the Caribbean, and my aunt is an award-winning filmmaker in Canada. My grandmother was a fantastic seamstress—I remember seeing outfits that she used to make because they were poor. But you know, like many women in the African diaspora, the pride is just overwhelming, so they could be dirt poor, but you'd think they were the fucking

queen when they walk out on the street, right? So she used to make amazing outfits, quality stuff. She used to lay out patterns on the kitchen table and teach her sons how to make shirts. My grandmother came to live with us in Edmonton when I was eight. She also taught me how to make shirts, how to make pants, and how to sew. I realized that creativity was part of her coping mechanism, out of necessity and pride.

So there's just a lot. Yes, you're right. There's a lot of creativity in my family. There's a lot of food and music and travels, and yeah, I guess I'm walking the lineage of my ancestors. I don't know if I'm supposed to be walking this path, but it feels like it.

Early in 2023, in collaboration with curator Umbereen Inayet, interdisciplinary artist and designer Javid JAH, and multidisciplinary artist and Wyandot Elder Catherine Tammaro, Roger created *The Burn*, an interactive installation using the universally sacred elements of fire and water. Three perforated geometric steel forms, 3.6 metres (12 feet) tall, with fires raging in their cavities, were erected for twenty-four hours at Nathan Phillips Square (the location of City Hall) in Toronto. The installation was open to the public, and participants were encouraged to set healing "intentions" upon a small symbolic cedar sphere before placing it into one of the geometric forms, where it burned to ash. The emanating smoke and the scent of burning cedar filled the square and the surrounding blocks. The sound design, by Roger and his music production partner, Jeff Eden (together known as Surgeon & The Butcher), featured three compositions using the solfeggio frequencies as their architecture. *The Burn* was a healing beacon of sound, light, fire, smoke, and sacred geometry. The ashes from the

installation will be distributed to several Toronto city gardens as a gesture toward completing the cycle of life.

Roger's intention with this creation was to provide a place for transformation, healing, and letting go of our collective experiences of grief during the ongoing COVID-19 pandemic. He was in Toronto setting up for the final leg of the multi-faceted installation when he received a call from his sister.

ROGER: She calls me and says, "You have no idea what's going on, right?" I said, "Well, clearly, I don't know what's fucking going on, and I hope you tell me." She goes, "Okay, sit down."

Turns out my parents have been fighting a lot—it's become a very tumultuous household. Then you add depression from COVID, health issues, mental health … it's not a good situation. My sister tells me that our dad went to my mother one day and said, "Don't worry, soon you won't have to worry about this anymore."

My mother replies, "What do you mean by that?"

He goes, "Don't worry. You'll see."

So my mom calls my siblings to tell them. My sister flies from Vancouver to Edmonton; that's where she calls me from.

She says, "You have no idea—this house is crazy. They fight all the time. His personal hygiene is slipping and … it's not good. It's a bad situation. Very bad situation. We need to intervene." She tells me what our father said to our mother, and once I hear that, I know it's crisis time.

My siblings and mother call the ambulance, and the ambulance folks insist they call the police as well. I know, stupid, right? And now he's asking my sister and brother, "How could you do this to me?" Because, remember, my dad had to do this to his mother when he was a kid. So

now the whole situation has come home to roost on him. Full circle. The situation is extremely volatile, and I am haunted by news reports of police mental-health calls that end in someone dying at the hands of those paid to serve and protect.

After two days of repeat visits from paramedics and police, he decides that he's going to go [to the hospital]. At the hospital, they started assessing him, because he hasn't been to the doctor in three or four years, so his feet are swollen to twice their usual size, from his knees down. He has health issues up the wazoo because he hasn't been to the doctor for years.

On top of his physical health, they're trying to assess his mental health and immediate critical need and figure out what to do. He's a brilliant guy. But he's older and is starting to forget things. So they're trying to understand if it's dementia or something.

This is a week before *The Burn*, when there's *everything* to do in Toronto; it is the most critical time. So now I leave [setting up] *The Burn* and fly to Edmonton. I spend Tuesday 'til Thursday dealing with the situation, and it's not good. My brother has an opinion. My sister has an opinion. My mom has an opinion. I'm trying to manage the whole family, manage the inter-interpersonal relationships between everybody that fucking cross-section with everybody else. I'm trying to deal with the Alberta health care system and trying to understand the situation. I'm doing my absolute best to ensure they don't put my father in the mental hospital unless absolutely necessary, because that's precisely what he had to do to his mother.

FRANCESCA: I'm so sorry to hear this. Where is your father now? Is he home?

ROGER: He's back home now. He was in the hospital for about three weeks. He was on informal suicide watch, basically, and for other health issues. They dealt with the most pressing issues, and we continue to manage the ongoing ones with the health care system. It was about keeping my parents separate 'til they could understand what was going on in the home and about having him on critical watch. For me, it was about keeping him out of that mental hospital—that would have broken him irreversibly. That's really a major aspect of what it was. Things are significantly better now.

Sometime last year, during one of our routine catch-ups when we sometimes talk about our childhoods and our family dynamics/dysfunctions, my brother I.K. told me he was reading *It Didn't Start with You* by Mark Wolynn.[14] He found it compelling enough to recommend that I check it out, so I did.

Similar to Menakem's work in *My Grandmother's Hands*, Wolynn's research focuses on inherited family trauma and how it impacts our lives. He introduces the idea that we can carry traumas from our ancestors in our bodies, which impact our health, relationships, and overall well-being. This inherited family trauma can go back several generations and, if unresolved, can manifest in our lives in unexpected ways such as unexplained phobias, repetitive patterns of behaviour, or even chronic illnesses. I'm reminded of this and saddened as Roger tells me of his emergency trip to Edmonton.

Although we begin with this difficult conversation touching on painful experiences, the second movement of *SoundBites* focused on matters of maturating and coming of age, opens with the

14 Mark Wolynn, *It Didn't Start with You: How Inherited Family Trauma Shapes Who We Are and How to End the Cycle* (New York: Penguin Books, 2016).

tongue-in-cheek "The Other Guy Returns," in the comical style of an opening sequence to a radio show about a superhero.

The accompanying painting, one of my favourites from this collection, is vibrant with orange, gold, and yellow. A swath of deep blue spreads across the right side of the canvas, bejewelled with thick daubs of gold. The contrast between cool and warmer hues is familiar and complementary. This is a highly textured painting, abstract with loose lines that join to form a figure that, though faceless, seems to be looking right back at us—perhaps a representation of the Other Guy.

> ROGER: "The Other Guy Returns" is a concept that references a previous album, *Eat Your Words*, which has a song called "Money On Black." It's basically the story of an underdog. It's about being around people who always get full credit for something you've made meaningful contributions to. So it's the underdog's song, you know, because I'm sick of that scenario. A line from the chorus says, "Everybody thought it was the other guy. And I was just the *other guy*."

I suppose that's a lesson we all learn, one way or another, particularly those of us who enter creative collaborations. Sometimes you are let down; sometimes your work isn't recognized or credited; sometimes you trust the untrustworthy person; sometimes you simply don't share compatible visions. Or sometimes, it's a mistake, a misunderstanding between flawed people trying to create something meaningful in a flawed world. More than once, I've lamented and raged bitterly when things I'd lovingly nurtured were usurped by someone I trusted. The myth of scarcity can have us at each other's necks or fearful of expanding an idea through the process of sharing, brainstorming, and collaborative experimentation from which it would greatly benefit.

On the other hand, the sting of regret from trusting the wrong person with your work, or the pain of witnessing your art soar without you is no match for the joy and fulfillment of reciprocal and complementary collaboration. It's stunning when an idea blossoms into something far more than you could have dared to imagine because it was given more nourishment than only one creator could reasonably provide. As the idiom goes, "Two heads are better than one, not because either is infallible, but because they are unlikely to go wrong in the same direction." Many eyes are more likely to see more details, and we know "the devil is in the details."

Clichés though these may be, their meanings remain true. I'm learning this in the second movement of my life—my early thirties being a second movement only if I'm lucky enough to pass middle age and eventually become an elder.

I often think of "Otherness" or the perception of Otherness in particular relation to my position as a Black person; as an Igbo and Yorùbá person; as someone from a colonized place living and creating in another colonized place; as someone with experiences of chronic pain; as a woman, a Black woman, a Black queer woman; as a settler; as a femme person. As an artist and storyteller whose work is inherently filtered through these and many other visible and invisible, acknowledged and unacknowledged facets of my identity.

I think of bell hooks's essay "Choosing the Margin as a Space of Radical Openness" from her seminal collection *Yearning: race, gender, and cultural politics*, wherein she describes her experience of living at the intersections of multiple identities, cultures, and communities.[15]

Legal scholar and critical race theorist Kimberlé Crenshaw coined the concept of "intersectionality" and explored it in

15 bell hooks, *Yearning: race, gender, and cultural politics* (Boston: South End Press, 1990).

"Demarginalizing the Intersection of Race and Sex: A Black Feminist Critique of Antidiscrimination Doctrine, Feminist Theory and Antiracist Politics," as did Chicana feminist scholar Gloria E. Anzaldúa in her book *Borderlands/La Frontera: The New Mestiza*. Anzaldúa used the term "borderlands" to describe the unique experiences of individuals living between different cultural, racial, and linguistic spaces.

For hooks, the borderlands represent the liminal space where she can navigate between her Black, working-class, and feminist identities and between the academic and activist worlds. It is a space where she can resist the limitations and expectations imposed by dominant societal norms and structures upon the "Othered." The borderlands serve as a site of resistance and creativity, allowing hooks to engage with different perspectives and to challenge traditional thinking. It is also a site to form connections and alliances with other equity-seeking folks and communities, a site for collaboration, not unlike my ongoing collaboration in Continuum Collective, comprised of Darcie Bernhardt (painter), Carmel (Nassim) Farahbakhsh (sound artist, violinist, and composer), Wren Tian-Morris (multimedia visual artist), and myself. Not unlike this collaboration between myself and Roger—a coalescing of ideas across multiple mediums, identities, beliefs, philosophies, and crafts to decipher some truths that will buoy us.

> ROGER: This is the resurrection of the Other Guy, who is returning to claim what's his. The track is an obvious turn in the album's narrative, because it's shifting from a childhood perspective to adult living.

"The Other Guy Returns" seamlessly segues to "Stuck On Stoopid," which is sonically more layered and complex than the first movement's songs, while maintaining a smoothness that's oh, so easy to groove to. It retains the playfulness of childhood

while pondering the higher stakes, the greater consequences, of adulthood decisions.

The art for this is another one of my favourites: a small painting of a figure sitting before a screen, the words "Toast Head" written in pink over the figure's back. The painting is saturated in cool shades of blue, purple, and pink, with some vivid yellows and greens on the screen. The rest of the piece is white negative space with two wires dangling from a lower corner of the painting, implying that the canvas is itself an unplugged screen. The simplicity of this piece exists in contrast to the micro story "More Bad Decisions," which reads like a puzzle or a word problem, providing intentional misdirections, only to conclude on the advantage of collaboration.

"The City 2.0" follows, opening with the sounds of a ticking clock and the ambient noise of a bustling metropolitan street—the blaring of a car horn, the ringing of a bicycle bell, the droning of a door buzzer. The beat climbs, muffled at first, then it bursts forth with astounding energy alongside a funky bass. There is no chorus, but for a surprisingly short and sparsely instrumental two-bar turnaround, the street noise works as a kind of hook that opens, pauses, and ends the track. "The City 2.0" is the counterpart to "The City," a track Roger made about twenty-one years ago.

ROGER: The lyrics of the first "The City" were:

red yellows and blues spread the news
women in business suits and high-heeled shoes
money change hands in stocks
on blocks
panhandlers shake cups to buy rocks
concrete and steel feel cold
the look in the passerby's eye unfold
tired of the runnin'

tired of the bills
tired of the tiring way the drama spills but
hungry for more never satisfied
the next man looking for ways to amplify

So it really is like a collage of imagery, of just walking through and living through the city. And I wanted to do "The City 2.0." I love that one so much I wanted to update it for this time, right? Because that was twenty-one years ago, I thought the city needed an update, you know, so here we are, living in the city. And as it starts again, it also repeats:

Reds yellows and blues
Spread the news
Passerby's stranded
Inflation that bruise
Sentimental strangers
Shooter infused

Digital ink spills all over the screen like
Streets been flooded
Gluttonous guts
All this influencer content influencing what
Sneaker disease
Sinning for cash
Beautiful ass
Everything broken like unusable glass

Horn heavy, with a slow pulsing tempo and drums reminiscent of a marching band, "I Cant Stand It" is another track on this album that showcases Roger's sheer love for rapping, as in the line "this is not work / This is love."

We live wholly and fully; there is no separation between work and life. This is one of the largest constructs that has been generally accepted. It's all just life. [Work and life] are fully immersive and not disparate.

In this song, replete with clever wordplay, he plays with sound and language with an adroitness that only experience can give. Roger's joy is infectious. This is another bop to which I find myself blissfully vibing. To me, it represents the idea of flow, a point in practice or even in growth when a person has found their rhythm. "The Method Is Madness," the micro story for this track, is tongue-in-cheek and equally playful in its vexation toward elitism. Inspired by Roger's experience as a chef who has to field many opinions on his pronunciation choices, this story's protagonists eat their tyrants in the end.

ROGER: I'm always toying with that frustration in a playful way, basically. And music is one of my main mediums [for it].

Playful, busy, erratic, noisy, boisterous, colourful, vivid, and dynamic—all qualities that can be used to describe Toronto, Lagos, and the visual art counterpart to "I Cant Stand It." The painting is all repetitive patterns, kaleidoscopic, with the texture of the canvas and the brush strokes visible and functioning to give it the appearance of a collage. The words "I Cant Stand It" float in the centre of the painting. Many of the multimedia paintings in this collection feature text, phrases, and words that reference the music or story. In this case, the text speaks to both.

Unlike "The City 2.0," which is not necessarily about one specific city, "Screwface Capital," featuring Mastermind, is a tribute to the city of Toronto. Brimming with site-specific references to the

most populous city in Canada, Roger pays respect to the place that shapes him in the second movement of his life.

> **ROGER:** I say Trinidad birthed me, Edmonton raised me, and Toronto made me an adult. So I wanted to make a song that really spoke to the place that raised me into the person you see. A lot of my work is formulated in that city. And it has a moniker of being the Screwface Capital, because it's known among musicians and performers all over the world that if you can come to Toronto and rock a Toronto show, then you can rock a show anywhere, because the people in Toronto will just look at you screwface if they think your shit is bootleg, like, they don't give a fuck. You could be anybody, and they just look at you blankly. So this is an homage to the Screwface Capital.

This is Roger's contribution to the tradition of artists paying respect to the cities and regions that have influenced their craft, and it's in excellent company, with the likes of Miriam Makeba's "Soweto Blues," Toumani Diabaté's "Mali Sadio," Third World's "Lagos Jump," Youssou N'Dour's *Egypt,* Ella Fitzgerald and Louis Armstrong's "April in Paris," Ray Charles's "Georgia On My Mind," Jay-Z's "Empire State of Mind," featuring Alicia Keys—the list truly goes on and on.

Similarly, in my writing and general creative imaginings, Lagos, the city in which I was born and raised, always seems to make an appearance. I like to refer to it as a beast of a city where you can find anything you want and everything you don't want. I have a complicated relationship with that city. In all honesty, I believe that everyone who is from, has ever lived in, or passed through Lagos has a complicated relationship with it. Known in Yorùbá as Èkó, Lagos has a population of over twenty-four million people and is on the path to becoming the world's most populous

city by 2100.[16] Although it is Yorùbá land, Lagos is a rapidly growing metropolis, an economic and cultural hub of the country to which many different people, regardless of their culture and ethnicity, have flocked for decades.

Much like "Screwface Capital" speaks to the idiosyncrasies of Toronto, its culture, and its denizens, artists across crafts and mediums have attempted to capture and translate the particular flavours, flattering and otherwise, of the spirit of Lagos, of Èkó. In literature, writers such as Sefi Atta, Teju Cole, Eloghosa Osunde, Leye Adenle, Oyinkan Braithwaite, Chimamanda Ngozi Adichie, Chris Abani, and many others have paid homage to Lagos City in their work.

"I no come Lagos come look Uche face," is an expression in Nigerian Pidgin that loosely translates to, "I didn't come to Lagos to look at Uche's face," which in turn means, "I didn't come to Lagos to waste my time." Like any other dense metropolitan area where folks from all over settle, Lagos is rife with a grind and hustle energy fuelled by the aspirations of millions as they navigate the city's particularly potent brand of fuckery.

"Played Out," the sixth track of the second movement, is rich, chord heavy, and immersive. Masterfully composed, it evokes a sense of being enshrouded by the music, cocooned within the layers of sound that oscillate between moments of quiet—where Roger's voice is barely a mumble—and crescendos of raw intensity. The boundaries between listener and soundscape seem to dissolve as one strains to make out the lyrics and is suddenly met with boisterous, rock-adjacent instrumentals.

ROGER: This is one of my favourite songs, because it's unexpected. It starts out ominous, with dark chords moving.

16 Max Bearak, Dylan Moriarty, and Júlia Ledur, "Africa's Rising Cities," *Washington Post*, November 19, 2021, https://www.washingtonpost.com/world/interactive/2021/africa-cities/.

The lyrics are very low in volume, forcing you to come physically closer to the speaker to understand what's going on. And by doing that, the sound envelops you. This was really a study of the physicality of music. Once you're in, [it becomes] a very unexpected moment; it turns into this fucking barrage of audio that smacks you. Then, again, it returns to this low-volume thing, forcing the listener in and out of this dynamic.

This sense of murkiness, of being swallowed by sound, is also present in the accompanying painting, which is composed of deep, dark streaks of maroon and burgundy, with thin blue line illustrations of two figures—one of which, to my eyes, resembles a ghost, a haunting.

"Fearless and lawless / Carefree / Carefree" are the first lyrics gorgeously crooned on "Fearless," the final track of this movement, followed by decisive and energetic bars that Roger spits over an explosive beat:

You know that I don't give a fuck kinda attitude
That you gotta have sometimes
Just so you can make it through
The bullshit
Oh shit
It's cold plus you naked too

ROGER: "Fearless" was really a study in manipulating time, because the tempo of the song is consistent throughout—it doesn't change—but the feel is so dramatically different. It's a study of how time can be manipulated by emotion. As a creative person, you know how sometimes you'll be writing, and then you look up and six hours have passed, but it felt like it was maybe twenty minutes?

FRANCESCA: Yeah, flow. It's what I crave when I'm working. To look up and see that time has passed so much, and I didn't even realize it.

ROGER: Yeah, because time doesn't exist, so we can manipulate our perception of the passage of time with our emotions. And once you release yourself from the constraints of time, it's very freeing. And when you have that kind of freedom, you become fearless.

There is archival footage of a conversation between Nina Simone and an unidentified interviewer that I've seen numerous times online. I know it well, but every time I watch it and hear her voice, hear what she has to say about freedom and fear, I am struck as if for the first time by the truth of her words.

INTERVIEWER: Well, what's freedom?

SIMONE: What's free to me? Same thing as to you. You tell me.

INTERVIEWER: No, you tell me.

SIMONE: It's just a feeling. It's just a feeling. It's like, how do you tell somebody how it feels to be in love? How are you going to tell anybody who has not been in love how it feels to be in love? You cannot do it to save your life. You can describe things, but you can't tell him. But you know it when it happens. That's what I mean by free. I have had a couple of times on stage when I really felt free. And that's something else. That's really something else.

Oh, I'll tell you what freedom is to me: no fear. I mean, really, no fear. If I could only have that for half of my life. No fear.[17]

I agree with Nina Simone, but I'm hungry for more—I want that for the whole of my life.

Freedom. No fear.

17 *Nina Simone: A Historical Perspective*, directed by Peter Rodis, 1970, video, https://www .dailymotion.com/video/x14hgds.

THIRD MOVEMENT:
THE LEAVING

ROGER: Well, the first painting I ever did actually was after my daughter died.

So … my son died. That was horrible. And then my daughter died. And that was—I don't know which is worse actually, the first time or the second time. But after that, it was really bad, of course. A horrible situation. You have to sit down and tell your surviving kids. Pretty bad. And so I needed to do something. I bought a big canvas, and I made this all-white thing that was layered fabrics, and to this day, that piece lives over the fireplace in our home. That was one of my ways of coping with that situation and bringing a little peace and the spirit of those children into our home. You know, I didn't realize how meaning-ful it was to my family until we moved from one house to another, and my wife said, "Get the painting and put it above the fireplace. I want that painting there while we move into the house." And it was the first time I realized it meant something, that it mattered, you know?

And yeah, that was the first venture into painting, and it helped me, so I just kept painting for myself. Then it started to reveal stuff to me. It continues to reveal stuff to me in ways that music and writing don't. I learned stuff about myself, and I also learned that you can do whatever the fuck you want to do if you really set your mind to it, you know? And I think the work that I've done on these—I'm happy with them. I'm proud of them. People seem to embrace them so far. And that's cool, you know? Because it's very personal. They're all very personal. So as an artist, you just put yourself out there, and whatever happens, happens. But I know I'm gonna go to sleep at night knowing I made stuff that I feel really proud of.

FRANCESCA: Thank you for sharing that. I can't fathom that kind of grief. I'm sorry.

ROGER: Yeah, it was horrible. It's the worst. Two things: I never fully understood when people say, "I would never wish that upon my worst enemy." I understand that now. And so, yeah, I would never wish that upon my worst enemy. Also, I never knew anything could hurt that much. I didn't know anything could hurt like that. Yes, it's horrible.

And again, it transformed my life. You know, like my moments with [my meditation teacher] Alec transformed my life. That was another major thing that was like, we changing the game again. But with Alec, I had to break down my person to rebuild a new person. [With these losses], I was completely broken down as a person. And I had to reconstruct everything I thought about the world. Everything, *everything*. Succession, order, the cycle of life, belief in God, faith, and humanity. People say stupid-ass shit, thinking that they're trying to help. You know, people got good intentions, but it's such an obtuse situation that people don't know what to say or do. They feel like they've got to say or do something and just … don't say nothing! Just shut up and just sit there; there's nothing you can do. So I learned a lot about people. But I wouldn't wish it on my worst enemies.

FRANCESCA: Roger, I'm so sorry. My heart is with you.

Roger and I sat in silence for a long while after he shared these losses with me. I cannot know the particular bitterness of his pain, but my heart is with him. It was the truest thing I could manage to articulate as I watched his face contort in pain while he spoke.

There are simply no sufficient words to hold someone else's grief with grace. Sometimes grief is a wound sewn shut with the tenuous threads of time, but neither Roger nor I hold sound beliefs in the concept of time as innate or unbendable, so what does that make of a wound?

The last movement of *SoundBites* is about the endings of things, or rather, the transition from one cycle to the next. Here, we're talking about death. I'm not afraid of death. Like most people I know, I've had people I love cross over. My exposure to death and dying began early in life, and through this I achieved an acceptance of it. I have a fascination with death that is not so much morbid as it is curious; I want to know what happens next. But I'm not in a rush to find out. So it's not the fact of dying and death that eviscerates me as much as it is, quite simply, the pain of losing loved ones, of not knowing when I'll see their faces again.

The first loss I can recall is my father; he died when I was about five. His death wasn't sudden. I don't know the whole story, but he'd been bedbound and receiving care from a home nurse in a curtained-off section of my grandparents' living room. I have foggy memories of this time. One day he wasn't there anymore. My grandmother sat me down and told me he had died. I don't remember what I felt or thought.

I *do* remember the funeral, being asked to toss a handful, maybe a shovelful, of dirt on his casket as it was lowered into the ground. It wasn't until that point that I felt something stir inside me, and I began to cry. I was overwhelmed by the attention the adults were giving me, confused because I guess I didn't understand what death meant. I don't know why it took the casket going into the ground for my body to register the finality of my father's time with us, but that was when I crumpled in tears. I was inconsolable; I remember that.

Opening with the tranquil sound of birds chirping, "When Words Fail," the first track in this movement, is a gentle, harmonious vignette. Roger's voice is rich and sombre velvet as he sings about silence for the thirty-seven seconds of the song. It's raw with emotion, with a kind of wisdom that can only come when you've seen some shit, when you've lived.

> ROGER: This is a moment in the album where I needed to turn the corner into the third movement. And I wanted something very peaceful, because we're coming out of a very kaleidoscopic, dynamic second movement and into something with softer, rounded edges. This piece of music was created with that in mind, shifting the brain from this erratic energy to a more stable, sombre point. It's very meditative.

Equally subdued is the visual art for this song, a dark, textured, monochromatic piece. There are four slightly off-kilter squares on each quadrant of the work, like windows, with images that resemble shadow projections of bare tree branches veining through them. It suggests a dark, wintry night, and the longer I look, the more to see; my eyes catch more detail, more complexity and meaning as I continue to observe. The initial semblance of simplicity proves to be deceptive.

"The Silence Knows," the twenty-one-word micro story that accompanies this work, feels as stark as the art, simple on its face, yet increasingly more complex as one considers it more deeply.

Similarly, "Imagine That" carries a sense of the poise and prudence that can come from maturity. This is a decidedly soulful track, from the mellifluous humming that runs through the entire one minute and seventeen seconds of the song to the slowed cadence of Roger's rapping over the down-tempo beat. This is

music that comes from a place of knowing; it possesses a certain weight of grief.

I think of this quote attributed to Danish author Karen Blixen: "All sorrows can be borne if you put them in a story or tell a story about them."[18] I think of the tradition of making sense and meaning of pain through the storytelling and creating that we human animals partake in. The poet Gregory Orr, in an interview on grief and craft, said, "What poetry says to us is, 'Turn your confusion, turn your world into words. Take it outside yourself into language.' Poetry says, 'I'm going to meet you halfway. You just bring me your chaos. I'll bring you all sorts of ordering principles.'"[19] From the musician Nina Simone, who openly transmuted her sorrows through music mastery; to poet Warsan Shire; to author Chinua Achebe; to former US poet laureate Tracy K. Smith; to my friends Shaya, a writer, weaver, and ceramicist, Portia, a storyteller and comedian, and Monika, a Mad artist; to Roger; to my brother I.K.; to my grandmother; to me; to you; we wring healing from at times unspeakable pain through our work. We utter the unutterable with the tools at our disposal. Isn't this how we survive? We cry about it; we tell stories about it; we draw pictures about it, make music about it, sing about it; we dig into the pain and make something grotesque or lovely or real or true.

"A Shame, Really," the micro story inspired by "Imagine That," is awash with themes of loss and helplessness in the face of larger forces of life and, ultimately, acceptance—fitting for this movement on finality.

The singular event that ignited what one might refer to as my political consciousness was the death of my older brother, Nnamdi,

18 This quote by Isak Dinesen (the pen name of Karen Blixen) comes from an epigraph that appears in Hannah Arendt's *The Human Condition* (University of Chicago, 1958).

19 Krista Tippett, "Gregory Orr: Shaping Grief with Language," *On Being with Krista Tippett*, last updated May 28, 2020, podcast, https://onbeing.org/programs/gregory-orr-shaping-grief -with-language/.

who was murdered by a Lagos State police officer in 2002. He and his friend, Morakinyo, were stopped at the police checkpoint just a block or two from our house. I don't know what conversation transpired between Nnamdi, Morakinyo, and the police officer, but I know that the officer opened fire, and neither Nnamdi nor Morakinyo returned home alive. My brother wasn't the only youth murdered by the Nigerian police during that season or since. Even before then, I'd known not to trust the police. However, after that night, I understood that they were actively dangerous and that a fraction of power in a landscape of fear and scarcity could render violent those entrusted to protect. I understood that we weren't safe in their care, and we had never been.

It wasn't until I moved to the US as a teen that I learned of the constellational nature of police violence and its roots in enslavement, colonization, and anti-Blackness. It was, it is, the same beast all across the globe. Tentacles of the same ideology have police forces in the United States, France, Brazil, Nigeria subjugating vulnerable people with violent and sometimes, most devastatingly, deadly force.

Unlike my father and grandfather's deaths, which occurred within five years of each other and didn't feel quite so sudden because they were adults and had been ill for some time, Nnamdi's death was a shock that my family is unlikely to ever recover from fully.

My middle brother, I.K., the musician, is only two years younger than Nnamdi. They were very close; they took care of each other. I think Nnamdi's murder affected I.K. most profoundly. He hasn't been the same since. It's been over twenty years now, but to my body, it's as though we just got the news last night. Time barely stitches this wound closed.

In 2018, I.K. released a concept album, *Hungry to Live*, in which he sank in and examined the pain of losing our older brother so suddenly and violently and his own journey to acceptance and

healing.[20] He gifted us this music, born from his grief and alchemized through art, because this is what we do—it's our birthright to create.

Preceding the final track of this movement is an interlude titled "Twice A Child." In late fall 2022, Roger asked me to share my thoughts on the proverb "Once a man, twice a child." This, the eighteenth track of the album, is my rumination on the adage. The art for this track is a blurred and distorted image of what appears to be three white ring-toss posts with black rings settled at their bases. The distortion calls to mind a glitchy, improperly rendered digital image, which gives the objects a sense of movement, as if the image were captured just as the rings were falling down the posts. I find the nostalgic tone of this piece resonant with ideas of childlike playfulness, a return to simple, easy joys—especially in the final dalliances of living.

Featuring Jully Black, "Black Death" concludes the final movement, but it is not a sad song. Keeping tune with the meditative rhythm of this movement, the slow tempo of "Black Death" is overlaid with Roger's poetry and the deep, rich silk of Jully's voice. The song opens with my own reflections on the concept of duality and is rapidly swept up in the melodious crash of an open high hat.

> **ROGER:** I wrote the lyrics to the song on the day my uncle Charles died. My aunt called me to tell me that he had passed. I was driving back home from up north when the concept hit me. The chorus and the words hit me, so I pulled up to the side of the road and literally started writing the chorus down, writing the hook down. Then I continued driving, and more words just kept coming. I pulled over a few kilometres down the road, sat in a

20 Ikon Ekwuyasi's *Hungry to Live (An Audio Documentary)* (2018) can be heard on Spotify: https://open.spotify.com/album/6TSVqj96ZnEDrk6HvNUKLv.

parking lot, and finished all the lyrics in, like, ten minutes. Finally, I got to the studio.

And then I called Jully because I'm like, I have this chorus, but it needs a singing hook that I can't do, because it needs *that* Black woman's soul. I knew that she had been going through a lot of personal stuff; that day, I found out there had been deaths in her family. So, also needing to find a life beyond grieving, Jully came on to the song.

It just has this beautiful masculine and feminine energy, the duality of white and black, the duality of bright lights and darkness. The transcendence of life through death or meditation, all of these things coming together and closing the whole game.

In black and shades of purple and grey, the visual art for the final track suggests a hyper-magnified image of a burnt or otherwise crumbling piece of matter. It suggests decay, a falling away, a peeling apart, a disintegration to ash. There is a kind of glow; wisps of light like the Milky Way emanate from one side of the corroding thing, and at its base are green embers as if from a fading fire.

At four tracks and a total running time of three minutes and eight seconds, this movement is the shortest and most barefaced. The overarching motifs of maturation, death/dying, transmutation, acceptance, and finality are present even in the final micro story, "Freedom," about a designer finding flow and completing the work of a dream. A fitting conclusion to this entire composition, the story, alongside the visual art, circles back to the subject of creativity as a lifelong practice, even a lifestyle despite—or better yet, in response to and supported by—the varying rhythms of life.

OUTRO:
STILL / ALWAYS CURIOUS

As a child, somewhere between the ages of eight and twelve, I used to get stuck on the reality that every moment, every second of my existence, was new and fleeting and *now*. I would become overwhelmed by my own consciousness; it felt like awakening to a certain level of awareness over and over. I don't know what that's called or whether there's a word for it. I would sometimes become awestricken by the astonishing fact of being alive, all the grimy visceral details of it, and the cosmic "What is God?" bigness of it. I was an anxious child but also easily delighted, and I still am. I am also still, to varying degrees at any given circumstance (and under any given influence), amazed at existence.

Reading was the first way I learned to peer into the minds and experiences of other people and ask, "Isn't this wild? Isn't it all so much? What do you think? How does your skin fit, and what do you see behind your eyelids? How does this feel to you? What does this all mean, in general and specifically? What are we doing here?"

A curious child, I had many questions and concerns, and I still do. This has brought me to artmaking, storytelling and writing, and collaboration with other artists, because in the practice of exploration through creativity (in the practice of *being*), I meet other explorers. If we're lucky, we can sit in conversation, share field notes, and maybe even co-create a signpost or a small etching on the path. Something to say, "We were here, this is what we found, and these are some of the things we wondered about."

These conversations with Roger are some of my small etchings on the path, though only a fraction of what we've talked about has made it into this essay. These are just some of the tangents we went on as we talked about *SoundBites* and its accompanying body of work, about artistry in relation to meditation, grief, death, ADHD, time, trauma, and family. These are just some of the places my mind wandered, reaching for wisdom from other writers, artists,

readers, thinkers, creators, friends, family, and collaborators whose existence shapes my existence.

In her novel *Parable of the Sower*, Octavia E. Butler wrote:

All that you touch
You Change.

All that you Change
Changes you.[21]

These are some of the things that have changed me. What are some things that have changed you?

ROGER: I've concluded that everything is fucked, so while we careen toward the apocalypse, I'm going to make art, because it brings me peace. And I hope that it brings someone else peace too.

FRANCESCA: Peace … I like that. I'm down to make art simply because I'm alive. I'll take all the good good I can get though, peace included, apocalypse or not.

21 Octavia E. Butler, *Parable of the Sower* (New York: Four Walls Eight Windows, 1993).

SOUNDBITES
by Roger Mooking

MICRO STORIES & ART

love parables and seemingly simple fables. For me, taking them in repeatedly always unearths a new thought. The simplicity is both relatable and deceiving. The mood, disposition, and circumstances of the reader on any particular day contribute to the experience. It is really collaborative art, where the observer becomes an interactive participant in further unravelling the truths embedded.

In actuality, it all begins with the music and the album *SoundBites*.

The titles of the following micro stories pull from the lyrics of the songs they are inspired by. Each micro story and its respective song share a similar sentiment, feeling, or insight. The pull quotes are snippets of song lyrics that connect all of the creative ingredients. Think of them as an amuse-bouche for the nineteen-course meal you are about to devour. Each visual art piece is the culmination of all of these seemingly disjointed parts. I assure you, everything is connected intricately.

If I am the spider and the web is this world, then the stories, art, and lyrics that follow are the silk. The idea was to make the music as visual as possible and to make the visuals and words equally as musical. I hope you enjoy this place. *SoundBites* is a celebration of chaos.

FIRST MOVEMENT

THE
LEARNING

PEACE

INSPIRED BY THE SONG "BLANK"

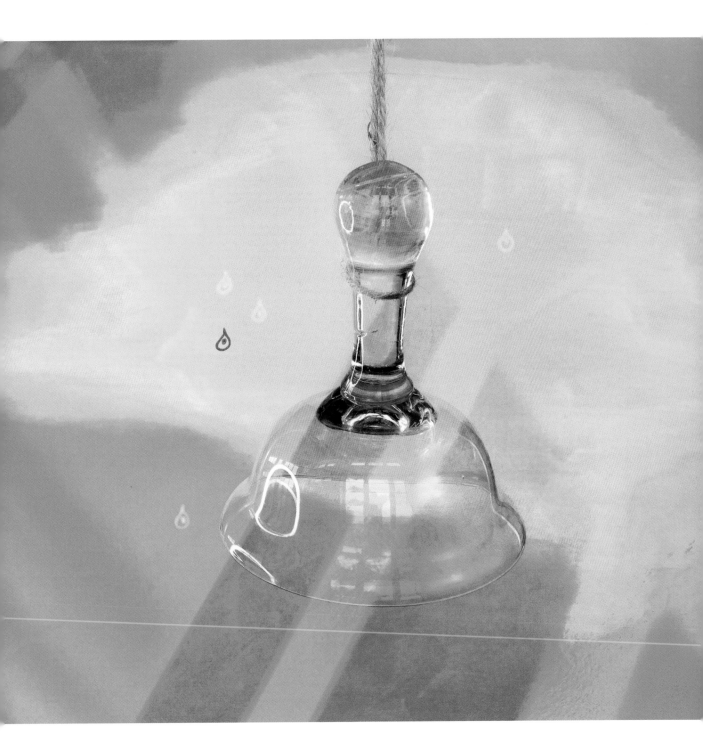

The boulder rolls heavy down the mountainside. It splits its head open without a sound. Rocky appendages flail as they fall to earth. Together they all rest, for eternity.

In the beginning . . .

THIS IS THE TIME

INSPIRED BY THE SONG "AQUATIC INFERNO"

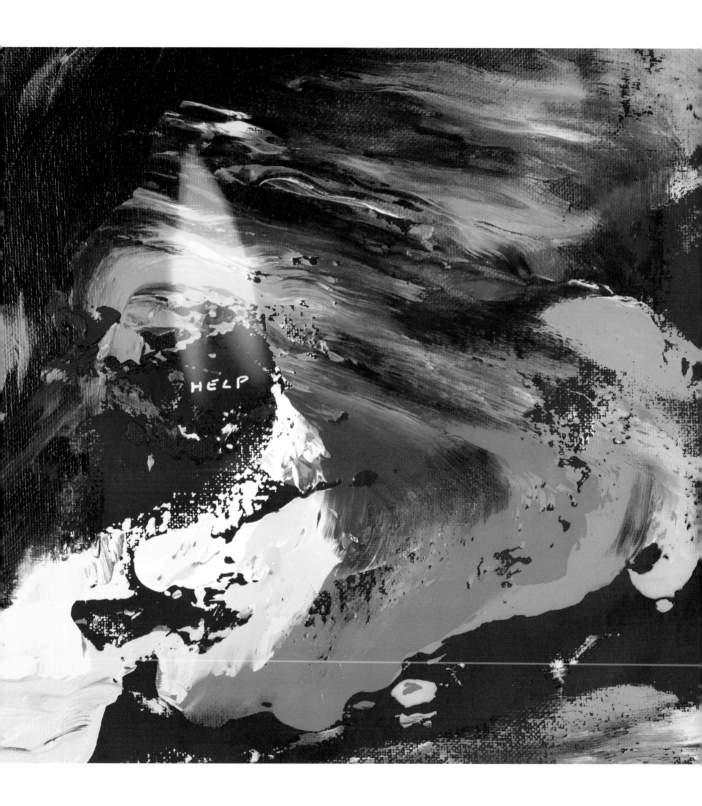

The diver and her family were poor. Like many others in similar circumstances, they lived precariously at the water's edge. They sought elevation. On a particularly capricious day, the diver dove and discovered an inferno. The fire, a newfound treasure, held her. She stared, breathless and wild eyed, at this miracle. She cautiously approached to see what was ablaze. Thrown by an eruption of fire and water, the heat wave breached and multiplied quickly. The diver was consumed. Swallowing deeply, she lived forever.

created by wonder

ISN'T THIS THIS AMAZING

INSPIRED BY THE SONG "ITS MY BIRTHDAY"

After playing themselves silly, the restless children finally fall asleep. When they awake, cool air fills their lungs, and they tumble anew into the day. Together they sing, they dance and celebrate, because it is their birthday.

At night, after playing themselves silly and with much insistence, the restless children finally fall asleep. When they awake, cool air fills their lungs, and they tumble anew into the day. Together they sing, they dance and celebrate.

all I see is life

I'M THE BOSS

INSPIRED BY THE SONG "IM AN ADULT"

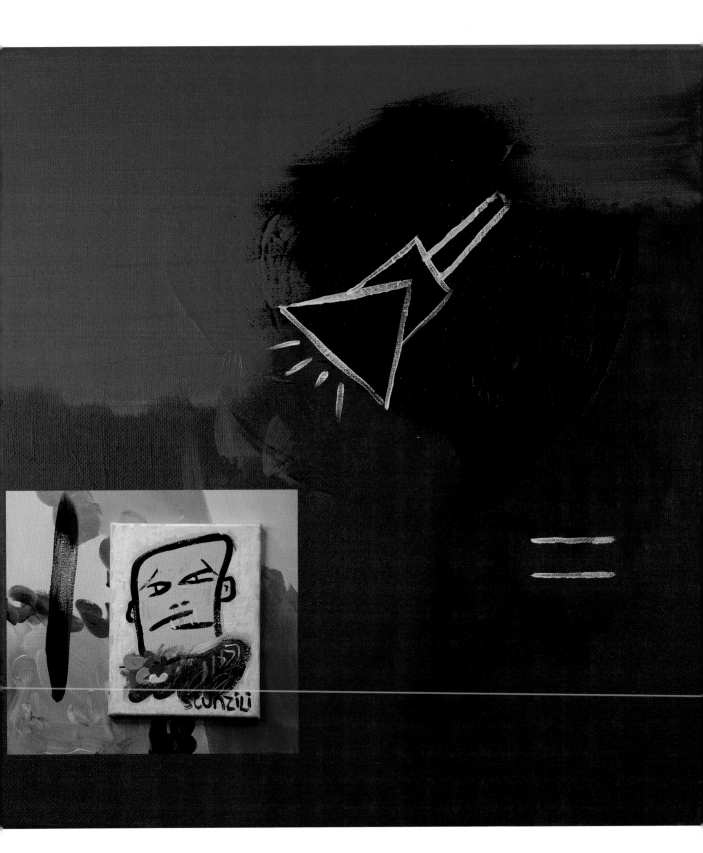

Eight ants climbed up a hill in an obedient row. The largest ant seemed to know the way; it was sure this was the same path they'd always trod. Certain of each bump and pebble to their destination, it led assuredly.

Upon arrival, the largest ant, turning to direct the others, found not even one in tow.

That's when the seven ants realized they were utterly lost.

I'm winging it just like you

BASED ON A TRUE STORY

INSPIRED BY THE SONG "FRANCESCAS READING ROOM"

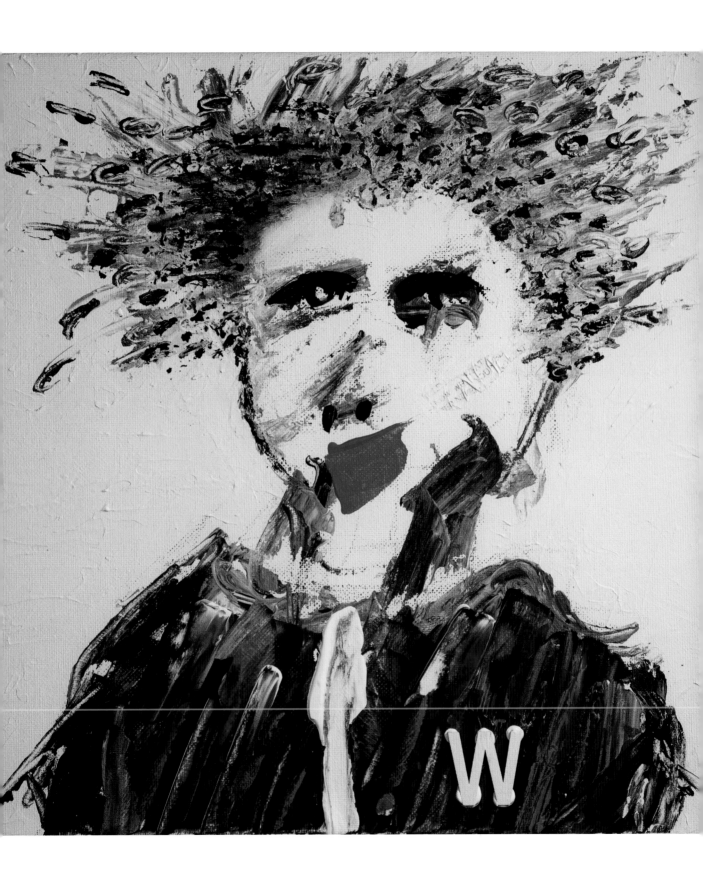

Mr. White, a seeker, read and read and read. Over time, he learned and learned and learned.

He realized, after many years, that he understood less and less. With this revelation, he made the impulsive decision to dedicate his life to excavation.

Enthusiastically he began his new life of picks, axes, ropes, headlamps, and hard hats. He was struck with another thought; a voice within him suggested, "Self, you should first read about excavating."

So, he hiked and read, hiked and read. Seeking the most spectacular cave, his foot found a hole. The voice again: "This must be it."

this one is a classic

A CURIOUS MIND

INSPIRED BY THE SONG "PRETTY PENNY"

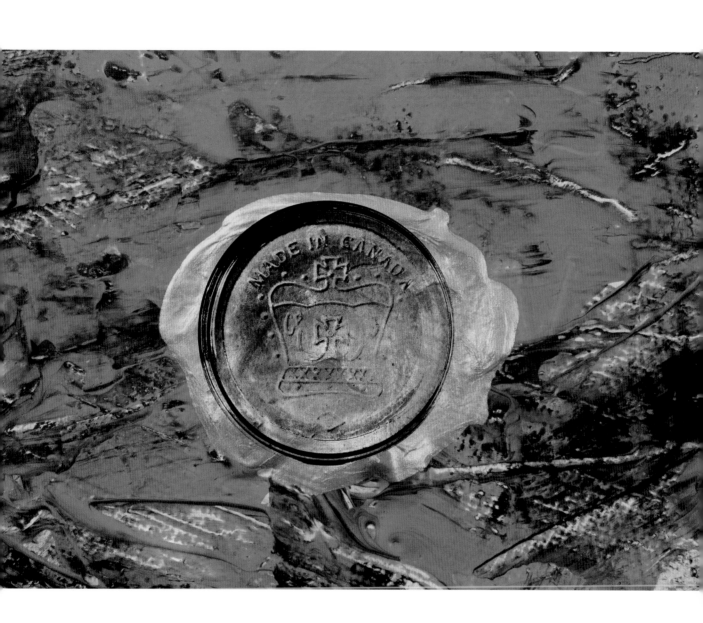

A curious child found a lump of gold shimmering by the river. Though it was brilliant and heavier than the jewellery he'd touched in the shops, the child didn't know the value of what he held. He found a pawnshop to trade it in.

The shopkeeper told him that the gold was a simple rock—he could relieve his burden.

After a long, uncomfortable pause, the curious child gave the shop owner his nugget.

The shopkeeper, smug with the success of having tricked a child, placed the gold somewhere safe. After some time, it was found by another rat.

*a penny so pretty
with spectacular shine*

TRAPPED BETWEEN

INSPIRED BY THE SONG "LISTEN TO GRANNY"

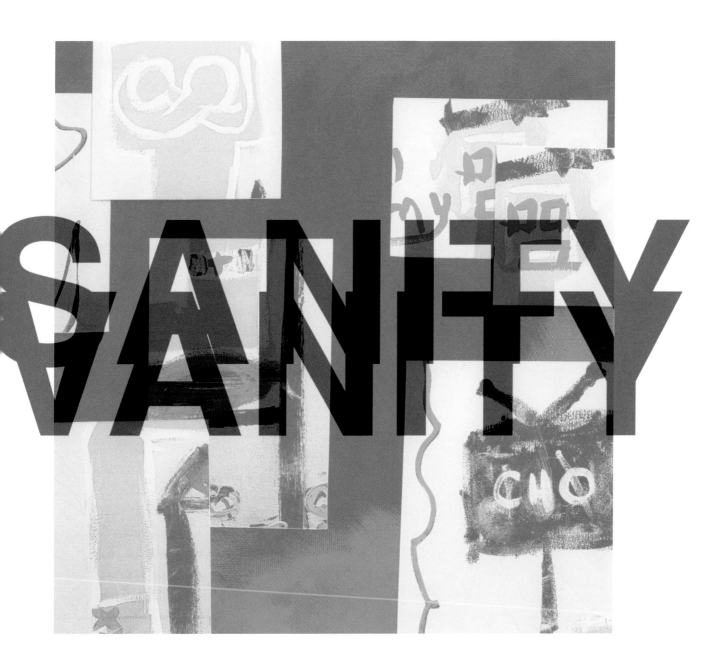

The intermittent sound was unfamiliar, both haunting and healing. On instinct, the villagers knew this new vibration was not just a nuisance. The sound stank. It left a bitterness in their mouths that was unusually delicious. Unable to comprehend the sensation, they sought the advice of the elders.

Their drinking and smoking interrupted, the elders doubled in annoyance. They demanded that the villagers leave them to bask in their rituals.

Over time, the unwelcome visitor forced the residents to grow accustomed to the frequency of the frequency. Eventually they came to love it. Patiently, annoyance melted away. Intently, they listened.

vanity and insanity

NEVER FLINCHING

INSPIRED BY THE SONG "PRACTICE DAILY"

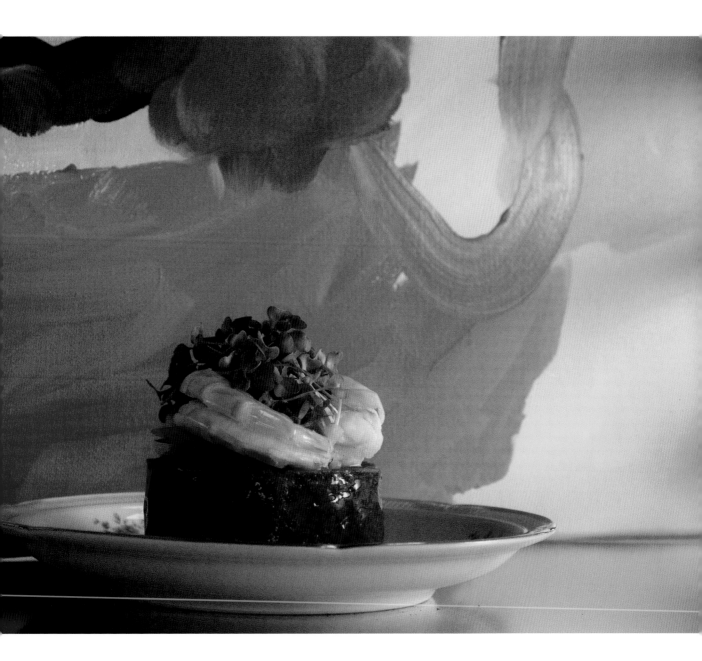

A man had a fat and irritable cat that was quite charming.

The cat came to love only one food; it refused everything else. The man fed his beloved's daily needs. They were both satisfied.

Thinking it was time and concerned that the cat might be bored, the man hastily forced new food into the cat's dish.

The cat glared and, surprisingly, shouted, "What kinda shit is this?!"

Undisturbed, the crafty man returned to feeding his cat its favoured fare. He gave the cat what it had come to expect.

The cat purred.

Before long, the man too was full.

**tighten up
ya lips**

SECOND MOVEMENT

THE LIVING

LOST SOULS

INSPIRED BY THE SONG "THE OTHER GUY RETURNS"

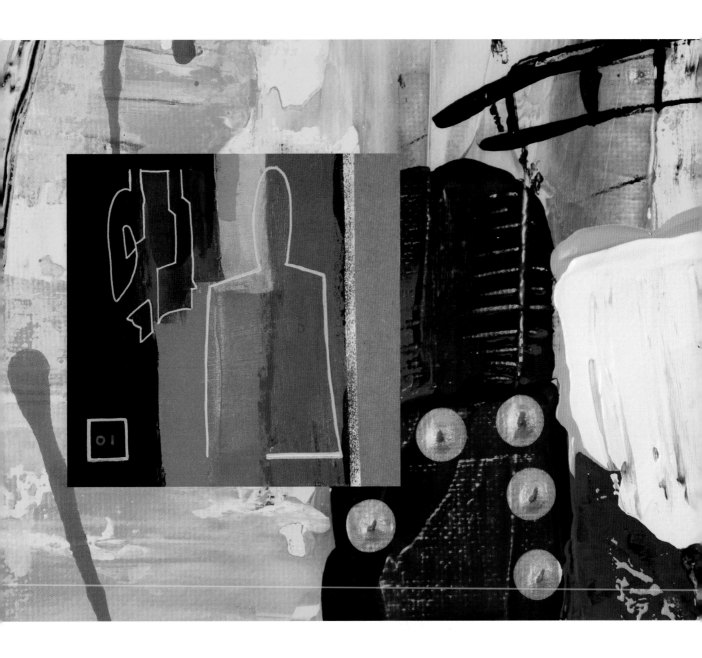

The underdog believes the dog is above. The dog believes that the master is above. The master believes they are the underdog.

who is

MORE BAD DECISIONS

INSPIRED BY THE SONG "STUCK ON STOOPID"

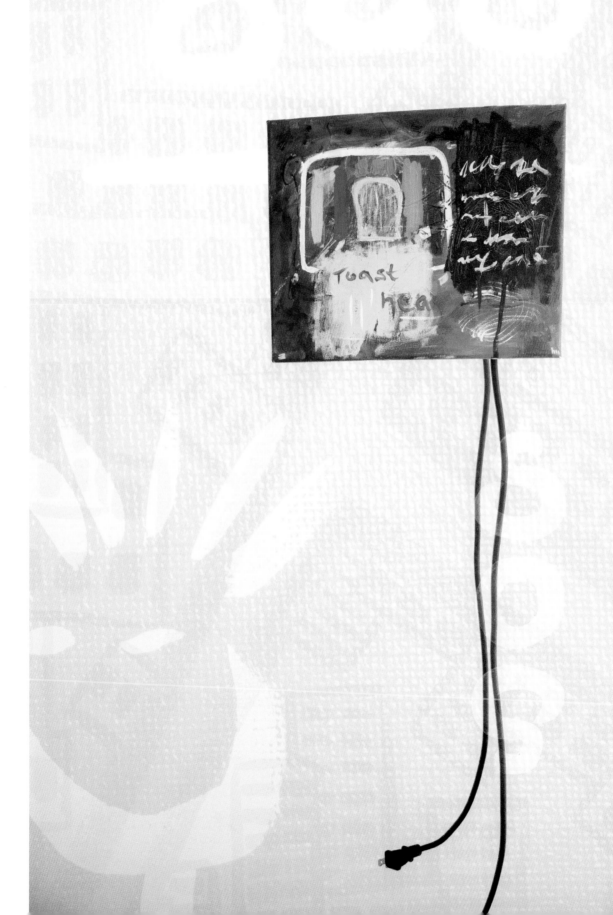

Eight boys in a deserted oasis play with matches at the pyramid's feet. They relish in the glowing *power, joy, and comfort* of fire.

The third boy is the strongest; he tells the eighth boy how lucky he is, how he needn't worry. The eighth knows he is the lucky one, but lacking strength, he demurs.

The first, second, and fourth boy believe in order; they surround the third.

For luck, the fifth, sixth, and seventh boys follow the eighth, not realizing that it is they who lead.

Worriless, lucky, and together, they plan to burn down the pyramid.

I guess you could wish for a bright side

RODENTS AND PYTHONS

INSPIRED BY THE SONG "THE CITY 2.0"

There once was a python who worked as a barber, the best in the field. Without hands, it tamed the wildest of manes. Daily lineups stretched beyond the shop walls and round the block. The python, wanting to protect its secrets, remained clandestine. It surrounded its chair with sheets and blindfolded each customer. Mostly, its secrets were safe.

There was a sly rodent who was envious. He spied on the python in silence for some time. Having hands, it decided it could work much faster than the snake.

The python had a rat and a rat problem.

**everything broken
like unusable glass**

THE METHOD IS MADNESS

INSPIRED BY THE SONG "I CANT STAND IT"

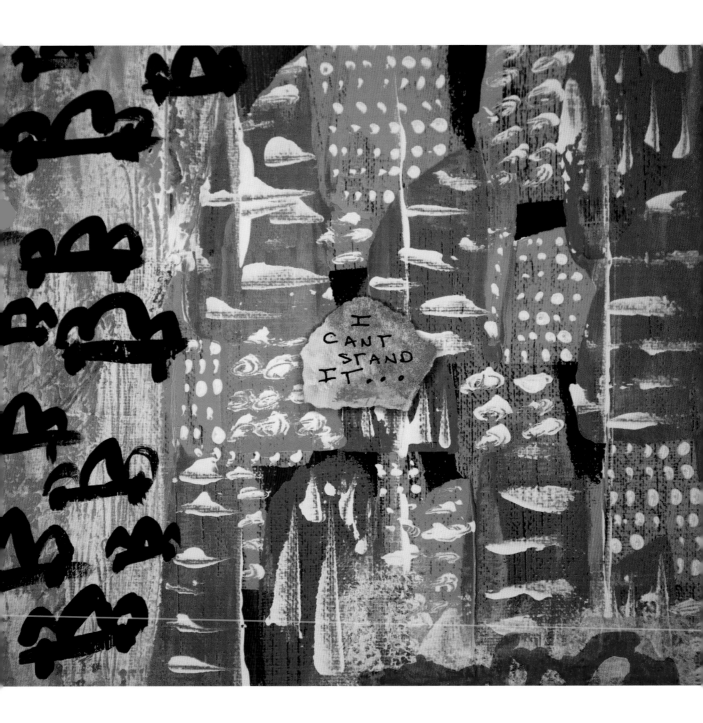

A brigade of chefs stand their ground and pronounce the H in "herbs." The aristocrats raise their hands to correct them, but the chefs repeatedly refuse and stay true.

Frustrated by the consistent disrespect, the chefs plot a revolt. Before they begin, they gorge themselves, revelling in their plot and savouring every morsel. Afterward the protesters roam the streets with bloody mouths, shouting, "We hate them, their hands and all!"

The aristocrats get their final wish.

**the mechanism
is exorcism**

THE PRETTIEST LIGHT

INSPIRED BY THE SONG "SCREWFACE CAPITAL"

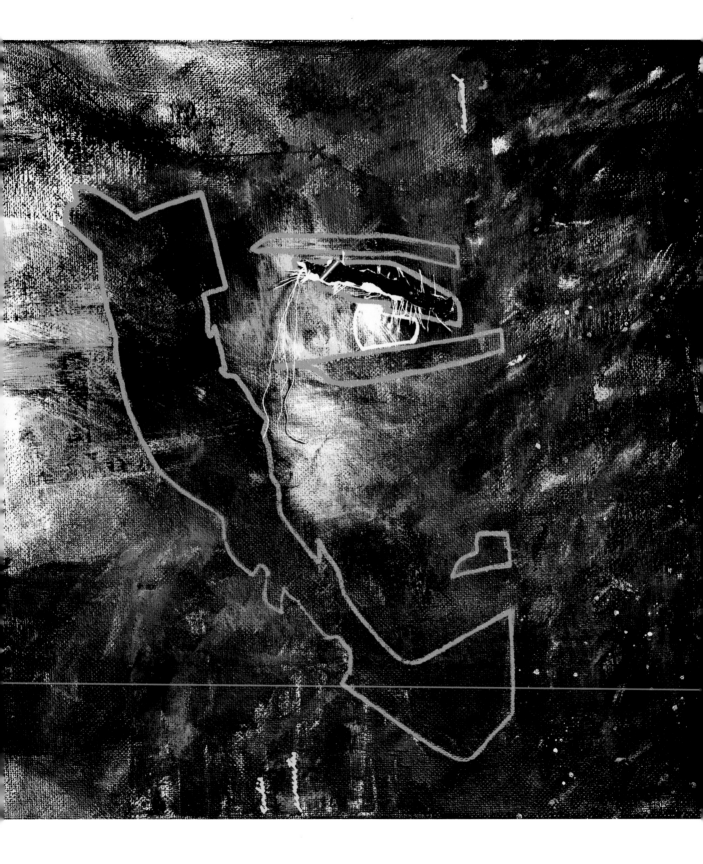

The monk says, "The one in the mask—I know that's the culprit."

"There is no way they did that," the gardener replies. "I was with them in meditation at sunset, and the goats were still there at that—"

"At that time," the monk interrupts, mocking. He continues, "Which sunset? Was it the golden one or the one before that?"

The gardener is shocked at the monk's ability to discern between the various sunsets.

"The sun shines the same on every face, masked or not," says the monk.

I'm from a city where

I MADE OUT OKAY

INSPIRED BY THE SONG "PLAYED OUT"

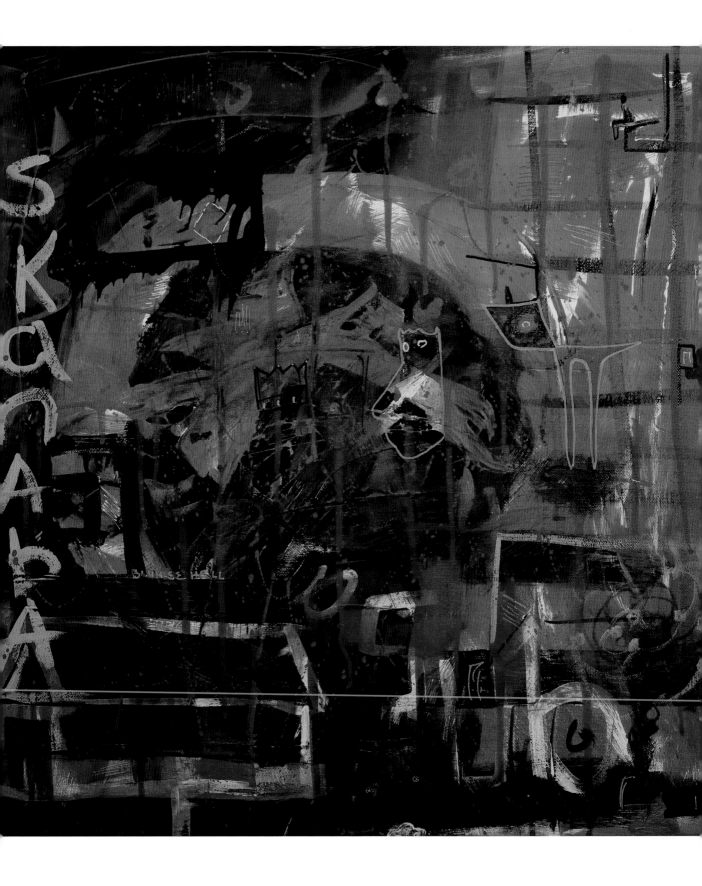

Imagining the unfathomable riches their boss enjoys, the disgruntled employees hold up the wall. Embittered by the imbalance, they seek equilibrium.

They bring their grievances to the manager, to no avail.

Next, they head up to the meeting room to demand, but make no progress.

Infuriated, they drive to the owner's lavish home, visions of victory ringing brightly in their minds.

Astutely, the owner embraces, spoils, and drowns the employees in rich liquor.

The following morning, the employees stumble back to their homes, ashamed and delirious.

After realizing their fleeting victory, they happily return to work the following day.

**they played
themselves out**

SAY WHAT THE HELL YOU WANT

INSPIRED BY THE SONG "FEARLESS"

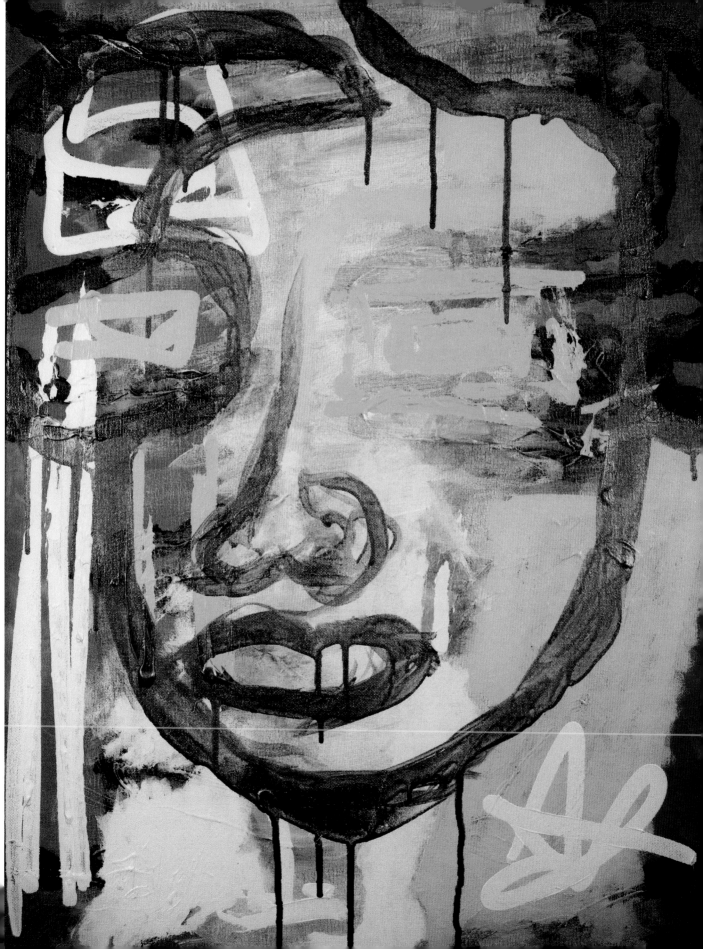

The town blowhard stood on a bucket with a brightly coloured megaphone. Notoriously blustering and convinced by righteousness, the crier coveted controversy and freedom. The ritual was daily. The controversy unfolded freely.

Frustrated, the candy factory in front of which the crier stood daily gifted the loudmouth a purse full of its most favoured treats. Uninhibited, the blowhard filled their cheeks to spilling.

Finally satisfied and with a full face, the silenced crier was left to emphatically wave their arms like a vulture preparing for takeoff.

The megaphone was finally free.

raise ya hand

THIRD MOVEMENT

THE
LEAVING

THE SILENCE KNOWS

INSPIRED BY THE SONG "WHEN WORDS FAIL"

The swing swings in the wind. The rope grips tightly, swaying like a metronome. Time remains still. They never speak.

the silence calls

A SHAME, REALLY

INSPIRED BY THE SONG "IMAGINE THAT"

Fields of corn swayed with force, yellow kernels in husky sheaths, tethered to their embrace. The golden sun, bursting brightly, matched their intensity.

Rain washed and nourished the cobs daily. The farmer was pleased with the crop's height, the soil's health, and the cheery rustling of the breeze. The field and the farmer were deeply in love.

The clouds, in their jealousy, choreographed a mutiny. They swelled, heavy, seeking praise. Weeks passed, unchanging.

Eventually the crop flooded, the farmer cursed, and the clouds bawled even more. The sun, betrayed, only dreamt of shining.

**something fishy
like a gypsy
doing voodoo**

DUALITY

INSPIRED BY THE SONG "TWICE A CHILD"

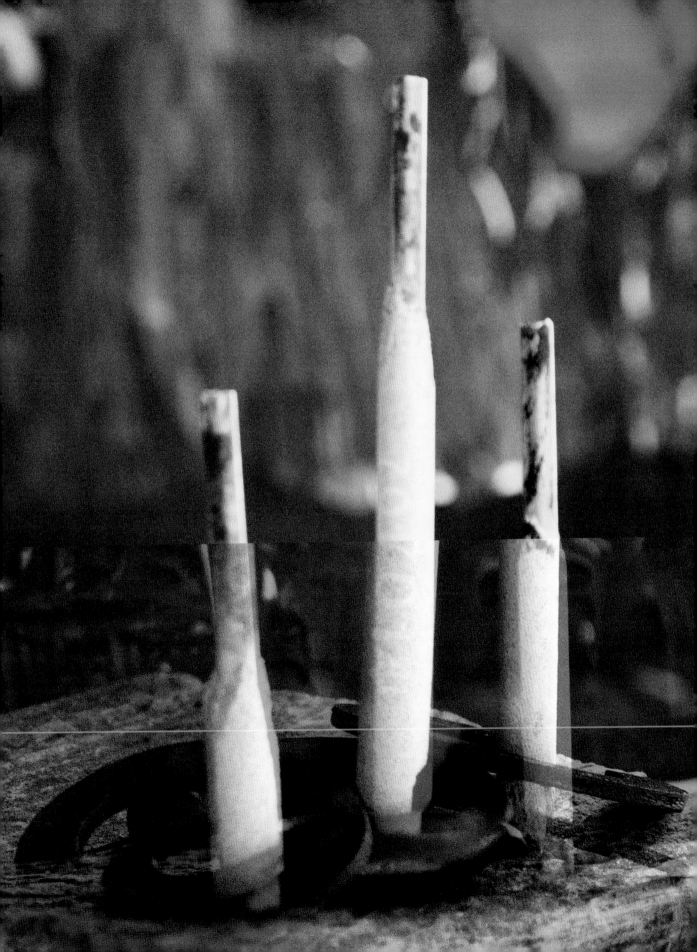

Everyone laughed at the preppers until *they* understood that they were ready. Having been here before, everyone remained unprepared.

**needing of
so much love**

FREEDOM

INSPIRED BY THE SONG "BLACK DEATH"

A dedicated designer dutifully drafts their dream. The drawing develops, demanding more of the designer's diligence. Deriving great joy from the unfolding discoveries, the dreamer's attention drifts while doodling. With expanding desire and deepened focus, the creator unknowingly drops deep into fluid space. A seductive departure, although sudden, is equally dreamy. Falling into the blackest hole, all remaining senses rise to find light. Delicious bliss overwhelms. The hugging darkness transforms into brightness, both decidedly present. In this moment the designer realizes the drawing has somehow delivered itself. It is done, magnificently complete.

**oh so beautiful
the blackness**

LYRICS

The lyrics of *SoundBites* follow an arc that cradles the cycle of life from conception to death. The themes, the rhythm of the words, their tone and related performances mirror the human experience, moving chronologically from the purest simplicity through a prismatic crescendo before settling in for reflection; the songs and their lyrics guide this trajectory. As the album progresses, the lyrical approach and performances match the moods of the cycle.

The first movement guides the listener from conception to adolescence. The Learning is decidedly spontaneous, juvenile, and frivolous as the narrator discovers their world. Lyrically, instrumentally, and with each performance, this introductory movement is decidedly direct. These lessons are fundamental to forming the individual whom we learn more about over the course of the entire album.

The Living, the second movement, welcomes the listener to experience the world beyond adolescence as they move precariously through adulthood. The complexity and narratives of the music become more potent, increasingly thoughtful, and energized. In this most active phase of our life cycle, the expression of dynamic experiences is explored most fully.

The final movement, The Leaving, begins with a meditative homage to silence and ends with a chuckle as we move beyond the body. The Leaving is decidedly soulful and pensive, bundled in the comforts of hope and what is left of optimism. The lyrics in the final movement are deeply reflective of the journey through all three of the movements. As the intimacy of the personal stories unravels, the listener can recognize aspects of their own life in it.

The final song is track number 19. Reduced to its single-digit numerological prime ($1 + 9 = 10$; $1 + 0 = 1$), the number 19 becomes number 1. The final song returns us to the first song, and the cycle of life repeats in perpetuity.

FIRST MOVEMENT:
THE LEARNING

Blank

This track is exactly eight seconds, marking the inspiration of this entire body of art. The single bell strike symbolizes the moment of conception. There are no words and no distractions, just the indication of the beginning of one's time. It is meditative and hopeful.

(instrumental)

Aquatic Inferno

This song captures the disorienting experience of being in the womb. Surrounded by muffled voices and cosmic knowledge, all possibilities beyond this experience are filled with wonder.

This is …
Time
When I get time we …
Get together and …
Time we get together and …
When I get to the other side …

Every single element
On Earth
In the trees
In the park bench
In the cement
In your body
In the ocean
In the air (this is the time) was created by …
Wonder
Wonder what it gonna be like
Yes you can definitely say we are glorified
Space

Its My Birthday

It's the narrator's first day outside of the safety of the womb, and the celebration begins. All things move forward from this day. It is implied that one's birthday is to be celebrated daily.

You know it's my birthday
My birthday
Happy anniversary to me
It's just an Earth day
Oh it's my birthday
My birthday
Happy anniversary to me
It's just an Earth day

Whoa
So isn't this amazing
Everything is so loud
It's like a cloud opened up
I'm so clean
Like I'm all soaped up
And all the love
I can all soak it up
We can all soak it up
'Cause

It's my birthday
My birthday
Happy anniversary to me
It's just an Earth day
It's my birthday
My birthday
Happy anniversary to me
It's just an Earth day

And it's bright too
So many things to get used to
Everything I left behind
Is outta mind
It's outta sight
Now
All I see is light
All I see is light
All I see is life

'Cause you know it's my birthday
My birthday
Happy anniversary to me
It's just an Earth day
Oh it's my birthday
My birthday
Happy anniversary to me
It's just an Earth day
Earth day

Im An Adult

As children, we believe the adults in our lives are wise and all knowing. With confidence and sometimes fraudulence, they tell us what we come to believe as truths. Eventually the narrator's parents confess that they don't know what they are doing in life either. This is a revelation fundamental to learning but also an introduction to skepticism.

Lemme tell ya
I'm an adult and I don't know shit
I'm like you
I'm just winging just like you
Get it

I'm an adult and I don't know shit
I admit it
Not sorry
Not one bit

I used to be you
You know
But not you exactly
But I mean
I was you
Practically
We're the same
My parents were lame
They thought otherwise
They had tight shirts with butterflies
And a button fly

And it wasn't fly
And they said words like fly fresh dope
Buzz off
Close the door
I'm trying to multiply

Why
Why you back again close my room
And knock to get back in
I know you pay the bills
You think I'm stupid
It's not by accident
And here's the phone bill
And I need some shoes
I can pay with tap
Or with ya Visa too
Plus I need tattoos

You need tattoos?
Do I look stupid
Where's the phone booth
Don't answer that
What I mean to say is
You better not answer back
Or this shoe
Is gonna find a spot
Right near ya back
And ya better not
Try it again
Or next time
I'm gonna have to call your mother …

That's an example of bad parenting

You know why
'Cause
I'm an adult and I don't know shit
I admit it
Not sorry
Not one bit

See
I'm an adult and I don't know shit
I admit it
Now go clean ya room
'Cause I'm the boss
Get it

I'm an adult and I don't know shit
I'm like you
I'm winging it
Just like you
I'm an adult and I don't know shit
I admit it
Not sorry
Not one bit

Francescas Reading Room

This skit sets the listener in the familiar, safe environment of a children's storytime at a library. It is a moment of release from the previous and impending tensions and sets up the fable of the next song, "Pretty Penny."

Welcome to Aunt Francesca's Reading Room. Now gather around, children, this one is a classic. Like many of the greats, the events are based on a true story.

Pretty Penny

*Our guide begins to understand the injustices of life, their symbols
and some of their impacts. The world slowly begins to reveal itself
as a less-than-friendly place as our host is introduced to even more
unexpected realities of daily life.*

In a faraway land in a time that's past
There was a little boy with a curious mind
He was out one day with his friends when they passed
A penny so pretty with spectacular shine

It was oh so special so his little hand reached down
And picked that penny up
It was heavy for size
Brushed the dirt off and he saw it was gold
With a lady and a crown on one of its sides

Hmmm … he thought to himself
Why this lady gets a crown and his momma can't buy shoes
His friends didn't know so they thought they would try
To figure out the story of this lady the muse

Asked all the grown folks what they knew of this old gold lady
But confusing things began to unfold
Granny loved her
Others said "It's complicated," no doubt
So they hit the library just to figure it out

Turns out her riches came sending gangs of thugs to
Kill, rape, mutilate, separate, hate
Murder, sell, burn down shit, behead and slaughter
The best part
She said religion blessed the torture

Told so many people they were garbage
And that happened for so many generations
They thought it was fact
While kicking 'em she threw all their stuff in the back
Of boats and golden chariots
Then thought she would rope

In a few other rich people to develop the scheme
Got richer selling diamonds, gold, souls between
They robbed another and another and her sister and her brother
Even made sneaky laws just to do it undercover

So now the little boy is torn with his grace
Does he carry on but with the shame on his face
So the boy with his smarts took the coin to his mother and said
"This is for you, Momma
You earned it"

Listen To Granny

As our narrator unravels their world, they seek the guidance of elders. The lessons taught are both powerful and confusing, formulating a resolve to understand the world with the grace and wisdom of a wiser generation.

Yeah, that's right baby, just uh, don't forget to call your granny. You know how she likes to talk. Just listen to your granny.

Trapped between
Vanity and insanity
The same way it is now
It was with my granny too
Granny one was a martyr
And granny two
Was even harder to get through to
Now if you do the math
It never adds up
And in two twos
You take one away
And when you do
You'll see that's true too
And had you been listening carefully
And read between the lines
When you were getting an earful she
Gave some jewels to run to
Like that Killer Mike and that EI-P LP 2 do
And if you do do
As I say and not do
Then you too
Can be remembered like Desmond Tutu

Practice Daily

*In the midst of forming their world, the narrator discovers
something so inspiring that they devote a daily practice to it.
This is discipline and passion coming to the fore. Practice leads
to mastery of craft, which leads to continued daily practice. This
song is a reminder that we find the most profound teachings in
day-to-day actions.*

I see ya ship is sinking
Lights are blinka-blinking
I'm here to put a crimp in
Like I was a lynchpin
Sicker than a lynching
My name you shouldn't mention
I'll just send the henchmen
They go throw the wrench in
They go do the winching
Tighten up ya lips and
They go do the cinchin'
And they never flinching
Wanna check the realness
So they get to pinchin'
It's not gonna work
Like ya pension

SECOND MOVEMENT:
THE LIVING

The Other Guy Returns

This song marks the turn into the second movement with a comedic skit reminiscent of a somewhat recent past. It serves as set-up for the next song, in which a heroic underdog is inundated with rampant stupidity.

In today's episode of *The Other Guy*, our underdog superhero saves yet another lost soul who is …

Stuck On Stoopid

The monotonous repetition of the key idea reinforces both its silliness and its ominous threat. Our guide is equally frustrated, fascinated, and resolved to their circumstance. The remainder of the songs in this movement are framed by that realization.

Stuck

on stupid on on

Stuck

on stupid on on

Stuck

on stupid on

Stuck

on stupid on stupid on stupid on stupid on stupid on stupid on

stupid on

Stuck

on stupid on stupid on stupid on stupid on stupid on stupid on

stupid on

Hey

Mister Humanoid over here

Thinking out loud for a sec

I guess the worst you can do is you might get upset

So here we go

When did everybody get to go nutso

I thought the whole goal was to get not so

Like a Nazi

Not so right on the right side of history

I guess you could wish for a bright side

But that would be stupid like making the same mistakes

Like killing brain cells just to save some space
Stupid

Stuck
on stupid on stupid on stupid on stupid on stupid on stupid on
stupid on
Stuck
on stupid on stupid on stupid on stupid on stupid on stupid on
stupid on stupid on

They say stupid is as stupid does
What does that mean
If you do something stupid
Then stupid you is getting a buzz
Or having a bad week
Time to recharge the battery
Which usually means more stupid decisions
But
Great stories
Great time and great fun
New traditions
More bad decisions
Better stop before you see the prison
Stupid
If you lucky maybe cupid
Pay you a visit and you can be stupid in love stupid

Stuck
on stupid on stupid on stupid on stupid on stupid on stupid on
stupid on
Stuck
on stupid on stupid on stupid on stupid on stupid on stupid on
stupid on stupid on stupid

Stuck

The City 2.0

*Removed from nature and explosive in its intensity and synco-
pation, this song immerses the listener in a barrage of visuals,
sounds, and thoughts that pervade concentrated living in urban
environments. The lyrics are a collage of snapshots of such
intensity that they engulf the listener in this way of life.*

Reds yellows and blues
Spread the news
Passerby's stranded
Inflation that bruise
Sentimental strangers
Shooter infused

Digital ink spills all over the screen like
Streets been flooded
Gluttonous guts
All this influencer content influencing what
Sneaker disease
Sinning for cash
Beautiful ass
Everything broken like unusable glass

Never enough
Scandal in immaculate homes
A shackle of bands
Snort powder
Clouded
Endless

It's never-ending
Bottomless refills
Legalized drugstores
Reefer and weed pills
Walk and text
Walkabouts amped with sex
Bodybuilders and bulimics
With charms to flex

Sinking holes
Anxiety like shrinking clothes
Flooded streets
Fashion with them things exposed
Foolish pride
Take chance Monopoly board
The rebel lies in waiting while the property soars

Box stack brights on
Rodents and pythons
God glory gumption
Keeping the lights on
Real love fake love
Still make love
Till the wicked flies up
Times up
In the city

I Cant Stand It

Moving beyond the conundrums of urban living, our host takes us on a playful adventure of skipping wordplay and humour, a welcome break from the intensity of the previous song. The listener is left with the feeling of watching folks frolicking in a field while the world spirals around them. The song is as much a break as it is a reminder to enjoy the moments that bring us joy—all while foreshadowing that perhaps it is all too much to tolerate.

Yeah
Turn up the mic like 2 dB
Yeah yeah that's good

Now this record is just a check for skepticism
I reckon the mechanism is exorcism
The method is madness
The goal is the best decision to bless ya system
And the rest
That's left for the restless
And the young
But the best is yet to come
Like the last person on ya guest list
Imagine
I do this in my spare time
Like a spare tire
One foot in one foot out
Like I wear a wire
First things first this is not work
This is love
I'm like a German with a knackwurst
Reliable like clockwork

And if the beat knocks

And the heat rocks

Play knock-knock

And I'm there

Then it's no joke

Leacock

Ya'll just peacocks

All show

Y'all so

So so

That if this was France

Ya names would be comme ci and comme ça

Except no one would come and see or come inside

And if you get it

Comme ça

I'm smoking rappers like a white owl

Or a brisket

Served up with a biscuit

Take it to task

It's like a tisket

If you didn't catch that

Again

You missed it

It's all about you huh like this is me time

I rap great

This just my free time

I know you're thinking this kid should really stick to cooking shit

Ya looking at it backwards actually my shit's cooking

And good looking

Get ya lip smacked a tic-tac

The kid's back

If I'm the shit then you a shit stain

Better not sit back

Screwface Capital

An homage to the city of Toronto. Many rites of passage, key features, and Gotham-esque likenesses are encapsulated in the lyrics. It's immersive and a poignant reminder of what makes a place "home"; often, home is where we meet the most love, as well as the most resistance.

I'm from a city where there's cars and bicyclist wars
The bathroom at Sneaky Dee's is like the syphilis ward
And the first thing they asking is
Are you the west or the east end
You know Drake or The Weeknd

The alleyways connect like umbilical cords
Got Soul in the City like it's filling ya pores
Damn
Cranes in the sky meets the cloud suites
Patty shops crumbling like Gardiner concrete

Box seats high like them knee socks
Blue Jays wishing for a pitcher with heat rocks
Rich and poor mix like yachts in the Portlands
Gentrified Parkdale hipster like Portland

See we been what's on next
The Screwface Capital feet staying on necks
Influence is drastic
The traffic is spastic
The park is Jurassic

Ya man is ya Mans
And we funny like slapstick
But don't get twisted
It's fishy like crab sticks too
It's magic
Still the prettiest light
We golden
That's what my city is like
Behold it

Why the Screwface Capital? I'll tell you why. Our standards are so high that when we see stuff that is subpar … the disgust when we saw something that wasn't dope and it would show on our faces. The Screwface Capital.

Played Out

Sometimes we find ourselves wallowing in mundanity. What usually follows is an explosion of extreme emotions and a feeling of release. This song gives the listener both experiences, fully, in a very short time frame. It is liberating and allows the listener to move into fearlessness.

Imagine a bunch of kids in a sandbox just playing and playing and playing. They play so much they use up all their energy. Played out. Is it you?

Slicker than James Bond
Drip with the shades on
Pocket thicker than Megan
First step in the maison
Yeah yeah you got something to blaze one
Get some dough with one of your liasons
You don't fake the funk
Fake the funk fake the funk
Tell the driver put Waze on

Who's played out
Why you looking at me
You better not be looking at me

I can go on for days and days on
THEY PLAYED THEMSELVES OUT
I stay fresh forever like a raisin
Watch me
I'm the TV when the game's on
And I stay so
So I never make the same song twice
That was the era I was raised on
The frequency I stays on
Wires crossed
Must of had that phase on

That's why all of y'all are phased out
I made out okay but y'all are played out
That's why all of y'all are phased out
I made out okay but y'all are played out

Who's played out
Why you looking at me
You better not be looking at me

Fearless

This is an experiment in the malleability of our perception of time. The tempo throughout the song remains exactly the same, but the chorus and verse feel unrelated and disparate. The lyrics guide the listener through the broad spectrum of our perception of time, moving from full rage to an easing of tension. Unapologetic, this song gives permission to be fearless and free of prescribed restraints.

Fearless and lawless
Carefree
Carefree

You know that I don't give a fuck kinda attitude
That you gotta have sometimes
Just so you can make it through
The bullshit
Oh shit
It's cold plus you naked too
And afraid
I told y'all before
Life is frightening ya brain
You can change your attitude
Love need to be added to
You can climb the ladder too
Start from zero latitude
This is not a platitude
This is not for platinum
This is for your right to say what the hell you want
Fearless

Fearless and lawless
Carefree
Flawless
Fearless and lawless
Carefree
Flawless

You know that we can do it all kinda attitude
That's the way we walk in rooms
That's the way we talk in rooms
Came that way right out the womb
Believe it we leave it to the believers
Canadian
Sorry we do not leave it to Beaver
Oh lord I need a hand
A royal flush could suit ya man
That's the attitude you gotta have sometimes
Just so you can make it through
That don't give a fuck attitude
Raise ya hand if you feel that way too
Pray if you feel that way too
Fearless

THIRD MOVEMENT:
THE LEAVING

When Words Fail

*On the verge of the last movement, we need a break from the
onslaught of ideas, emotions, and chaos. This song reflects on
the power of silence, being alone with oneself, and the loss of
expectation. It simply exists, frictionless and breathing.*

Sometimes the best words are silent
Like the night when it falls
Sometimes the silence calls

Sometimes the silence is louder
Than the wind when it blows
Somehow the silence knows

Imagine That

Deeply reflective and personal, this song and its lyrics examine the nature of interpersonal relationships. As one ponders their life and the people who have inhabited it, sometimes we stumble upon conclusions that are unexpected and without satisfactory resolution.

We die many times
It's like a thousand deaths

Ya just don't get it do you
I see you and my pupils go through you
Something fishy like a gypsy doing voodoo
Who knew
Treading lightly
But stepped on a land mine that blow through you
Boom
I got X-ray vision
Protected like a bishop with a sex tape
Now it's checkmate
Sinker hook line by ya breastplate
Got 'em
It's a shame really
Shouted all my feelings
Still you can't hear me
But does that even matter
Well I guess not so much
Well
Anyway
Just my chest is like heavyweight
With no belt

No prize

And no bell

Ding

No countdown

It's kinda like "The Message" but with no Mel

Imagine that

It's kinda like "The Message" but with no Mel

No Mel

No message

Twice A Child

As a bridge between reflection and the inevitable, this song forms the intellectual architecture for what is only imaginable. The similarities between the first movement and the last movement are made clear as we move to close the full circle of living and dying.

I think of being a small child that's just heavily dependant in order to survive. I think of old age as a sort of second childhood, perhaps can be as helpless as an infant again. Umm … and needing of so much love and care and support … that's what comes to mind.

Black Death

*Apparently, death is similar to deep meditation: expansive,
seemingly never-ending, and with equal parts torture and bliss.
This song shows us that darkness contains its equal duality of
light; these two seemingly opposing forces are born of the same
spirit. In the end, we are boomeranged back to the beginning, and
this feeling can be achieved during life through meditation.*

Duality gives meaning so we understand darkness 'cause we
understand light.

White lights
Bright lights
But it's a Black Death
I'm seeing
White lights
Bright lights
But it's a Black Death
Oh so beautiful the blackness

You see there's two childs in every tactile body
Trying to act out
So they act wild
Till the adult back down
And they get back acting up
They're like actors

It's like a Black Death
From a spider bite
Arachnid
Another black widow
Soaking the pillow
Not an accident
There's no words

I'm seeing
White lights
Bright lights
But it's a Black Death
Oh so beautiful in blackness

These two childs excite themself
But they always butting heads
It's bottomless
Oh so holy
Their button heads
Fighting for the final breaths
Like a tidal wave
Overwhelming in the final phase
Only primal left

I'm seeing
White lights
Bright lights
But it's a Black Death
Oh so beautiful this blackness
I'm seeing
White lights
Bright lights
But it's a Black Death
Oh so beautiful this blackness

Acknowledgments

I'm immensely and eternally grateful to my family.

Thank you to my brothers, I.K. and Nnamdi; my cousins Chinedu, Ene, Ichuckwu, and Kiki; my grandmother, my aunties, and my uncles. Thank you to my mother and father. Thank you to my ancestors.

Thank you to my chosen family and beloved friends Monika, Seyi, Hannah D, Portia, Shaya, Wren, Nass, Dar, Biyi, Emmanuel, Kayza, Ariane, Ry, Lee-Anne Poole (LAP), Alanna, Jess, Abi, Kit, Marshall, Hannah G, Christine, Patricia, and so many more lovely humans who have invited me into their lives.

Thank you to my sweetheart, Kayl.

Thank you to new and old pals and collaborators.

Thank you to Roger for inviting me to create this work alongside you.

Thank you to my agent, Rachel Letofsky.

Thank you to the wonderful folks at Arsenal Pulp: Brian, Cynara, Jazmin, Catharine, Robert, Erin, and Jesmine.

Thank you all, named and unnamed, for witnessing me, for spending time with and encouraging me, for listening to my stories and sharing yours. Thank you for being here and being you and allowing me to be me—flawed, inconsistent, odd, silly, and so on and so forth.

I hope you like what I've written.

I love you,

—francesca

Thank you to every single moment and person I've stumbled into. Some linger, some leave, and some love. We are all connected beyond time and quantumly entangled. Cherishing every moment with you all, especially those closest to heart and home, makes living a worthy tumult. If I love you, you already know. Love Only Beyond This Point.

—Roger

About the Authors

ROGER MOOKING is a Trinidadian-born, Canadian-raised talent who creates immersive experiences in the arts. Roger has earned an international reputation as a multi-faceted creator. As an award-winning and celebrated chef, restaurateur, television host, author, and recording artist, he showcases a globally inspired vision that reflects his rich family heritage and love for people and travel. Recently, Roger has made his mark in the world of interactive art, cultivating immersive experiences that merge visual, sonic, and culinary arts. He is a contemporary renaissance man. *rogermooking.com*

Photo credit: Lumenville Inc.

FRANCESCA EKWUYASI is a learner, artist, and storyteller born in Lagos, Nigeria. She was awarded the Writers' Trust Dayne Ogilvie Prize for LGBTQ2S+ Emerging Writers in 2022 for her debut novel, *Butter Honey Pig Bread* (Arsenal Pulp Press, 2020). *Butter Honey Pig Bread* was also a finalist for a Lambda Literary Award, the Governor General's Literary Award for Fiction, and the Amazon Canada First Novel Award and longlisted for the Scotiabank Giller Prize and the Dublin Literary Award. CBC's Canada Reads, an annual "Battle of the Books," selected *Butter Honey Pig Bread* as one of five contenders in 2021 for "the one book that all of Canada should read." Championed by Roger Mooking, the book made it to the grand finale, where it placed second. *ekwuyasi.com*

Photo credit: Lena Szymoniak